HIDDEN HISTORY
of
SALEM

HIDDEN HISTORY of SALEM

SUSANNE SAVILLE

Published by The History Press
Charleston, SC 29403
www.historypress.net

Copyright © 2010 by Susanne Saville
All rights reserved

Front cover: Crowninshield's Wharf, detail, 1806. *Courtesy of the Peabody Essex Museum, Salem, Massachusetts.*
Back cover: Courtesy of the Library of Congress and Susanne Saville.
All images are from the author's collection unless otherwise noted.

First published 2010

Manufactured in the United States

ISBN 978.1.59629.062.4
Library of Congress Cataloging-in-Publication Data

Saville, Susanne.
Hidden history of Salem / Susanne Saville.
 p. cm.
Includes bibliographical references.
ISBN 978-1-59629-062-4
1. Salem (Mass.)--History. 2. Salem (Mass.)--Biography. I. Title.
F74.S1S38 2010
974.4'5--dc22
2010034790

Notice: The information in this book is true and complete to the best of our knowledge. It is offered without guarantee on the part of the author or The History Press. The author and The History Press disclaim all liability in connection with the use of this book.

All rights reserved. No part of this book may be reproduced or transmitted in any form whatsoever without prior written permission from the publisher except in the case of brief quotations embodied in critical articles and reviews.

No son of Salem, wander where he may, will be called to blush at the mention of her past. Come what may, there is only pride and inspiration in recalling that. Come what may, be she a laggard or a leader in the race, her history will never lack a quickening zest.
—*Robert S. Rantoul*

Contents

Ensorcelled Salem	9
The Myrmidons of Colonel Leslie	18
A Country Called Salem	27
Fallen Angel	40
Surprising Salem	54
Salem's Chinese God	71
Entertaining Salem	75
Literary Salem	96
Edible Salem	114
Cats of Salem	122
All that Remains…	127
Notes	137
About the Author	143

Ensorcelled Salem

Into the land and atmosphere of Witches…

Salem is synonymous with witches. There's just no getting around that. Historically, the city has tried. Campaigns emphasizing its maritime past, its lovely coast and its collection of Asian export art have all jostled for visitors' attention, with not one word included about 1692. Some people actually seem to have believed that if Salem toiled hard enough, the witch trials would be forgotten.

Yet somehow, despite the lack of any central monument to the event, that scab on Salem's memory refused to heal and disappear. So at the 200th anniversary of the witch trials, members of the Essex Institute decided, why not embrace it? They suggested a memorial lookout tower on Gallows Hill. The plan described a rough-faced stone tower, forty-five feet high with a twenty-foot square base and an internal staircase. Upon climbing to the top, one would be gifted with a scenic view of the surrounding countryside and the ocean. Their argument for the monument ran thus:

> *The belief in witchcraft, and the death-dealing methods by which it was sought to eradicate it, is a part of the history of the world. Salem witchcraft…has become the most popularly known outbreak of any age or in any land. It will never be forgotten for it never can be. Annually thousands of persons flock to Salem to stand upon the sites made memorable by the occurrences of the witchcraft epoch. It is to set right the minds of these visitors and to instruct them, and the members of our own community*

Pioneer Village, Salem. *Courtesy of Library of Congress, HABS MA-1315-1.*

as well, in the lessons to be learned from the history of the delusion of 1692 that the Institute seeks to erect this memorial tower.[1]

This scheme was met with resistance from those who thought such a monument would only perpetuate the association of Salem with witch atrocities. How can you expect people to forget if there's a great big stone tower in the way? "The whole affair ought to be cast into oblivion as too horrible to contemplate; a shame on Salem and our community."[2] So the monument was shelved, and Salem went on with the laborious task of trying to make the world forget.

The world proved to be rather recalcitrant. The next hundred years only scrawled Salem's association with witches more indelibly into the popular consciousness. To begin with, Daniel Low, a local jeweler, started offering a Salem Witch Souvenir Spoon designed by his son, Seth F. Low, on October 1, 1890.

Ensorcelled Salem

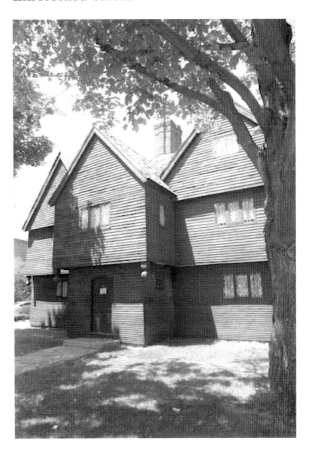

The Witch House, residence of Judge Jonathan Corwin. *Patrick Stanbro, www.patrickstanbro.com.*

The issuing of souvenir spoons began about 1851 with the Crystal Palace Exhibition in London. American travelers started bringing them home, and collecting such spoons grew to become a turn-of-the-century fad. The Lows, along with M.W. Galt of Washington, D.C., are primarily responsible for this. Their souvenir spoons were so successful that they inspired the industry to take root in America. You can still find souvenir spoons at tourist destinations across the United States today.

Low's first pattern witch spoon consisted of the word Salem with a witch and three pins on its handle. He immediately received orders from all over the world. Encouraged, his second pattern was even more elaborate. This time the handle was decorated with a cat, a broom, a rope (hanging), pins, a moon and a witch. And engraved in the bowl of the spoon were the date and place. On January 13, 1891, Low registered his "Witch" trademark and then proceeded to produce the first souvenir catalogue, full of Salem Witch silver.

Early colonial interior. *Courtesy of Library of Congress, HABS MASS,5-SAL,20-9.*

People who came to Salem and picked up a spoon clamored to make a physical connection with something dating to the witch times. Despite being somewhat hidden behind a Victorian apothecary, witch trial Judge Jonathan Corwin's house (the Witch House) attracted enough visitors for its owner Jesse Upton to give tours.

Hoping to redirect this need to see history, Salem created its Pioneer Village. This was one of the very first historical theme parks in the United States, complete with costumed reenactors. It was carefully set in 1630, of course. (*Forget, world, forget!*) Not that the general public would bother to split that hair.

Then there are the beauty products. Witch Cream, trademarked by C.H. & J. Price of Salem and first available in 1892, was "a delightful skin lotion" that would "restore beauty and freshness to the skin" for men, women and babies. Indeed, as well as being soothing, nourishing and healing, the advertising copy promised that Witch Cream could take care of frostbite, sunburn, eczema, pimples, wrinkles, prickly heat and salt rheum.[3] This wondrous product was still selling as late as 1953.

Ensorcelled Salem

The year 1937 saw the creation of Early American Old Spice, a line of toiletries for women. About 1940, the company ran an advertisement with an illustration of a beautiful woman clad in a simple gown hanging by a thick noose from a gnarled tree, her long dark hair discreetly covering her face and a rose clasped in one of her dangling hands. Beneath this image were the words:

> *HUNG! as a witch—*
> *Much too much for the Puritans of Salem—*
> *Her charming witchery quite overcame them,*
> *"Enchantress of Satan," they said, "Ah me!"*
> *And hung the lass to a sycamore tree.*

The ad copy then alerts the reader that you, too, can possess "the radiant charm that baffled our Founding Fathers" if you buy these particular toiletries. Salem witches—too sexy to live. Not your standard historical interpretation. But once again, Salem and witches are linked.

In literature, you have your pick of Salem-based witch books. And not just books. If you missed Charles Wakefield Cadman's libretto for a "grand opera in two acts" titled *A Witch of Salem* (1926), there was Arthur Miller's stage play *The Crucible* (1953). As *The Crucible* became required reading in many American schools, so Salem and the witch hunt were cemented together. Not that they'd ever truly been apart. And then there's the television show *Bewitched*. Samantha Stevens has her own statue in downtown Salem now.

So finally, at the 300th anniversary of the Salem witch trials, the twenty victims who died through the judicial process were given a memorial. Nineteen of them had been hanged for witchcraft, and one had rocks piled on top of him until he was squished to death.[1] The names of those who died in jail while awaiting their trial or execution are not present, nor are the names of the more than two hundred people who were arrested but survived.

For some, "survived" was a relative term. Little Dorcas Good was four years old when she went into the prison. Her mind was never the same. Mary Watkins and Susanna Davis had to literally sell themselves in order to raise the money to pay their jail fees. The same man bought them both.

After all this, over three hundred years of contemplation, what could possibly still be hidden about the Salem witch trials?

The location where the hangings took place. Salem worked so diligently at forgetting the site where the horrendous deeds were done that it has been lost.

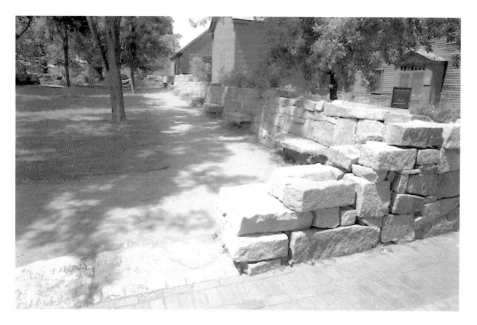

Salem Witch Trials Memorial. Each "bench" slab in the wall represents a person executed. *Patrick Stanbro, www.patrickstanbro.com.*

Gallows Hill, also known as Witch Hill, is assumed to be the site where the accused were hanged. But the traditions that grew up around it are all significantly after the fact by at least one hundred years. They also tend to involve urban legend degrees of separation between the teller and their source. (John Adams's sister-in-law's brother told him…Dr. Holyoke said John Symonds said that his mother said that her nurse said…)

The hill itself does not seem a very promising location when you get right down to it. In 1867, Reverend Charles Wentworth Upham described Gallows Hill like this: "It is hard to climb the western side, impossible to clamber up the southern face. Settlement creeps down from the north, and has partially ascended the eastern acclivity, but can never reach the brink. Scattered patches of soil are too thin to tempt cultivation, and the rock is too craggy and steep to allow occupation."

It was no better in 1692, and it would have been incredibly difficult to get a cartload of people up such an incline. It also would have been difficult to find the number of trees necessary upon which to hang them, the soil being thin and the hilltop being elsewhere described as barren.

Ensorcelled Salem

> **CONFESSION OF SALEM JURORS, &c.**
>
> *From Calef's "Salem Witchcraft." Page 294.*
>
> "Some that had been of several Juries, have given forth a paper, signed with their own hands, in these words:
>
> "WE whose names are under written, being in the year **1692**, called to serve as jurors in court at *Salem* on trial of many; who were by some suspected guilty of doing acts of witchcraft upon the bodies of sundry persons.
>
> "We confess that we ourselves were not capable to understand, nor able to withstand the mysterious delusions of the powers of darkness, and prince of the air; but were, for want of knowledge in ourselves, and better information from others, prevailed with to take up with such evidence against the accused, as on further consideration, and better information, we justly fear, was insufficient for the touching the lives of any: Deut. xvii. 6., whereby we fear we have been instrumental with others, though ignorantly and unwittingly, to bring upon ourselves and this people of the Lord, the guilt of innocent blood; which sin the Lord saith in scripture, he would not pardon: 2 Kings xxiv. 4; that is, we suppose in regard of his temporal judgment. We do therefore hereby signify to all in general (and to the surviving sufferers in special) our deep sense of, and sorrow for our errors, in acting on such evidence to the condemning of any person.
>
> "And do hereby declare that we justly fear that we were sadly deluded and mistaken, for which we are much disquieted and distressed in our minds; and do therefore humbly beg forgiveness, first of God for Christ's sake for this our error; and pray that God would not impute the guilt of it to ourselves nor others; and we also pray that we may be considered candidly, and aright by the living sufferers as being then under the power of a strong and general delusion, utterly unacquainted with, and not experienced in matters of that nature.
>
> "We do heartily ask forgiveness of you all, whom we have justly offended, and do declare according to our present minds, we would none of us do such things again on such grounds for the whole world; praying you to accept of this in way of satisfaction for our offence; and that you would bless the inheritance of the Lord, that he may be entreated for the land.
>
> "Foreman, THOMAS FISK, THOMAS PERLY, Sen.,
> WILLIAM FISK, JOHN PEBODY,
> JOHN BACHELER, THOMAS PERKINS,
> THOMAS FISK, Jun., SAMUEL SAYER,
> JOHN DANE, ANDREW ELLIOTT,
> JOSEPH EVELITH, HENRY HERRICK, Sen."
>
> [Not dated.]

Apology by the witch trial jurors. *Courtesy of Library of Congress, LC-USZ62-54810.*

A contemporary, Robert Calef, described a hiccup in the proceedings: "The cart, going to the hill with these eight to execution, was for some time at a set; the afflicted and others said that the devil hindered it."

Sidney Perley points out that, being as the terrain was so rough, there should have been no surprise if the cart was "at a set" (stuck). Therefore, for people to think the cart was held back by supernatural means, the land must have been normally easier to cross. And consequently not Gallows Hill.

There is also no crevice where the bodies could have been flung. Again, Calef reports:

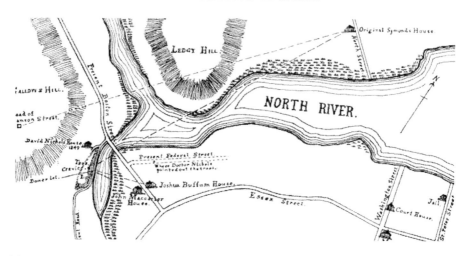

Map to the location of Gallows Hill. *Map drawn by Sidney Perley.*

> *When he* [George Burroughs] *was cut down, he was dragged by the halter* [noose] *to a hole, or grave, between the rocks, about two feet deep, his shirt and breeches being pulled off, and an old pair of trousers of one executed put on his lower parts; he was so put in, together with Willard and Carrier, that one of his hands and his chin, and a foot of one of them, were left uncovered.*[5]

Gallows Hill is also a little distant from where the North River ran. The crevice where the bodies were thrown was supposed to have been near water, because it was said some relatives snuck up the river at night and ferried their dead away in boats so they could secretly be reburied.

This isn't to say the general area is incorrect. The sheriff would have been concerned with performing the hangings outside of town. The North River, which at that time ran near the hill, was considered such a boundary. Once the sheriff crossed the bridge to Boston and beyond, he could have turned left and immediately found what he was looking for.

Overshadowed by the prominence of Gallows Hill is a small hill that, in 1921 when Sidney Perley was researching the area, had a crevice. It was also much nearer established roads, wouldn't have been too difficult to access and sat right along where the river used to flow.

This hill was easily seen across water and lowland from John Symonds's house (whose mother's nurse said she saw Brigit Bishop hang when she looked out her window). The little hill also was the backyard, basically, of Joshua

Ensorcelled Salem

Buffum, and Buffum family tradition holds that he could see the uncovered bits of body referred to earlier from his house. He is also said to have helped the accused relatives recover the bodies from the crevice and deposit them into the boats. Even closer to that hill was John Maccarter's house, a house that he sold for significantly below market value on November 12, 1692. Possibly witnessing four months of hangings from his back windows got to be too much.

Visitors would be hard pressed to find this little hill today, as the landmarks have changed considerably. For one thing, most of the North River has been paved over. So perhaps it is a simpler pilgrimage to walk up Gallows Hill, which became a park in 1912. Of course, then you'll discover that today the top of the hill hosts…a baseball diamond. (*Forget!*)

The Myrmidons of Colonel Leslie

So in one ship was Leslie bold
Cramm'd with three hundred men in hold,
Equipp'd for enterprize and sail,
Like Jonas stow'd in womb of whale.

To Marblehead in depth of night
The cautious vessel wing'd her flight.
And now the sabbath's silent day
Call'd all your Yankies off to pray;

Safe from each prying jealous neighbour,
The scheme and vessel fell in labor.
Forth from its hollow womb pour'd hast'ly
The Myrmidons of Colonel Leslie.

Not thicker o'er the blacken'd strand,
The frogs detachment, rush'd to land,
Furious by onset and surprize
To storm th' entrenchment of the mice.

Through Salem straight, without delay,
The bold battalion took its way,
March'd o'er a bridge, in open sight
Of several Yankies arm'd for fight;

The Myrmidons of Colonel Leslie

Then without loss of time or men,
Veer'd round for Boston back again,
And found so well their projects thrive,
That every soul got home alive.
—*John Trumbull,* McFingal

The third Monday in April is a Massachusetts and Maine state holiday known as Patriots' Day. It commemorates the Battle of Lexington and Concord, which occurred on April 19, 1775. This battle is traditionally seen as the beginning of the American Revolution. But there is another event, earlier and often overlooked, which could be said to be the Revolution's actual start.

The minutemen raising the draw on Salem's North Bridge were probably too excited to notice the chill in the air on Sunday, February 26, 1775. A quick clatter of hooves on cobbles had announced the coming of a rider bearing the breathless news: General Gage had dispatched Colonel Leslie and the Sixty-fourth Regiment of Foot to confiscate the Massachusetts militia's gun and cannon hoard at Salem.

With roughly two hundred[6] soldiers marching on them, in short order an equal number of minutemen had gathered on the north side of Salem's North River, ready to defend their stash of arms. As Colonel Leslie was approaching from the south, they raised the drawbridge and removed any nearby rowboats, effectively preventing the redcoats' ability to reach them on the opposite bank.

Colonel Leslie was not amused, as you might imagine.

Alexander Leslie was brother to the sixth Earl of Leven and Melville. His military career had taken him far from his native Scotland and stuck him at Castle William in Boston Harbor. He was there for the Boston Tea Party, which he described: "The Sons of Liberty went in a large body when dark to the wharf where the 3 Tea Ships lay and in 2 hours destroyed all the Tea on board, amounting to 340 chests…I had the regiment ready to take their arms if they had been called upon. I am since informed the council would not upon any account have the Troops come to Town."

Instead of facing action, for seven weeks Leslie ended up protecting, feeding and housing—with money out of his own pocket—the tea agents and customs commissioners who, fearing physical harm, had fled to Castle William. He wrote to General Haldimand requesting to be reimbursed for these expenses but was denied. Apparently he wasn't supposed to care what

happened to fellow government officials. He responded, "Your Excellency's determination for not allowing me the Expense incurred here on account of the Tea matter, must teach me a little more prudence for the future, and I am sorry to confess, it is not the first time I have played the fool in the same manner."

Now Leslie and his troops had been sent against the Sons of Liberty. Under strict secrecy, they had left Castle William in the dark of night and, on this quiet Sunday afternoon, landed at Marblehead to begin their march to Salem. You might think it would be difficult to hide their advance. "The uniform worn by this corps was very handsome, scarlet coats, white waistcoats and breeches, black leggings buttoned above the knee, stiff leather stocks, and tall bear-skin caps with brass scutcheons in front bearing the device of a crown and lion passant and the motto *Nec aspera terrent*."[7] However, this was Sunday, and they counted on the colonists all being at meeting. And not looking out their church windows.

Alerted to the situation, Major John Pedrick saddled his horse and set off to warn Salem. He rode at a dead run cross country, jumping walls and letting his horse have its head on the hills. When his shortcut met up with the road to Salem, he found himself in the rear of Colonel Leslie's troops.

Leslie and Pedrick were acquaintances, so when he saw him, they exchanged salutes. How was that possible, you ask? Leslie had been to Salem before.

One of the consequences of the Boston Tea Party was the Boston Port Act, which went into effect June 1, 1774. This not only closed the port of Boston and made Salem the sole major port but also made Salem the capital of Massachusetts. Having moved the governing legislature and court to Salem, Governor Gage took a house just outside the city, and Leslie and his regiment encamped nearby.

Unfortunately for Gage, Salem was not the pliant capital he wanted. He thought the Salem businessmen would be thrilled at all the income this would mean for them. Instead, Salem's leading men signed a petition saying they did not want Boston to be closed, as they could not honorably profit from another's distress. It didn't work.

Meanwhile, the rebellious legislature decided they needed to reach out to other colonies. Hearing whispers of what they were up to, Gage sent a messenger to order the Salem legislature to disperse. They locked him out. The messenger read the dispersal notice on the front steps, to no avail. On June 17, the Salem legislature voted to convene a Continental Congress.

The Myrmidons of Colonel Leslie

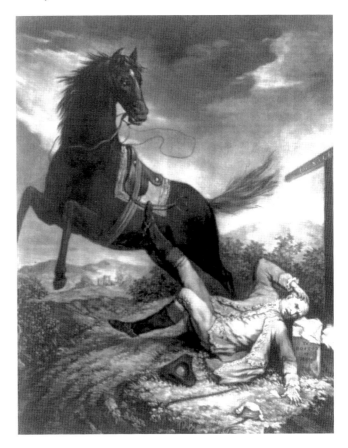

"A Political Lesson." The rearing black stallion of Massachusetts has thrown its rider (Gage) over the transferring of the capital to Salem. Note the storm brewing overhead. *Courtesy of Library of Congress, LC-USZ62-45380.*

Originally set for September 1, the Continental Congress met in Philadelphia on September 5, 1774. At which point Gage gave up on Salem and moved himself and his troops back to Boston. Salem, however, was not done with Gage.

In October 1774, in another show of independence, the Salem legislature renamed itself the Provincial Congress. This Provincial Congress created the Committee of Safety, tasked with secreting "warlike stores"—stores like the gun and cannon cache Leslie was sent to appropriate.

On the high road outside of Salem, Leslie must have been able to tell Pedrick was in a hurry. So he ordered his men to "file to the right and left and give Major Pedrick the pass." Always thinking of others, Colonel Leslie. In this case, however, he might lose more than his money. The way having been politely cleared for him, Pedrick continued his ride to warn the Salem minutemen.

Which is why when Leslie arrived to cross the North River, the drawbridge had already been pulled up. Leslie demanded the colonists lower the drawbridge. They refused.

He told them they had no business obstructing the king's soldiers on the king's highway. This devolved into a debate as to whether the road was in actual fact the king's, because it had been paid for by the residents of the north bank, not the city of Salem, and therefore, technically, was not a public road but a private one.

Colonel Leslie was even less amused.

He tried to wait them out, perhaps thinking the colonists might get bored with this game or too frozen to carry on. It was a very cold day, and his troops were shivering. Hours passed, and the minutemen only got more aggressive. Despite being warned not to "wantonly irritate the troops," some Salemites called out, "Soldiers, red jackets, lobster-coats, cowards, damnation to your government!"

Colonel Leslie told Captain John Felt, the Salem man in charge of the resistance, "I will go over this bridge if I stay here until next autumn," adding, "I will take the two stores on West's wharf as barracks before I'll quit without crossing."

"You may wait as long as you please, nobody'll care for that," Felt answered dryly.

"By God, I will not be defeated," snapped Leslie.

"You must acknowledge that you have been already baffled," responded Felt.

There was some muttering, and Felt caught the use of the word "fire." "Fire, you had better be damned than fire! You have no right to fire without further orders. If you fire you will all be dead men, for there is a multitude, every man of whom is ready to die in this strife."

This is one of those turning points in history. If Colonel Leslie had been a different sort of man, first blood in the American Revolution would have been drawn in Salem at this moment. Leslie had orders, his mission was being obstructed and these colonists were in open, armed revolt against the king's authority. He could have opened fire.

But he didn't.

Apparently, he decided no one should have to die this day, civilians or soldiers. So he offered Captain Felt a compromise. Colonel Leslie's orders specified that he cross North Bridge with the objective of seizing the hidden stockpile of guns. By this time, the guns most likely had been spirited away to

The Myrmidons of Colonel Leslie

Site of old North Bridge, Salem. *Courtesy of Library of Congress, LC-D4-18869.*

a more distant hiding place. So if Felt would allow the Sixty-fourth to obey their orders by marching across the bridge, Leslie would then turn them around and march them back without hurting anyone or confiscating their arms. His orders would be fulfilled, guns would still be in the possession of the militia and everyone would get what they wanted out of the situation.

Captain Felt agreed. A line was drawn on the ground, and the drawbridge was lowered. Colonel Leslie's troops marched across North Bridge, wheeled at the line and started back. Some of the residents of the north bank took this opportunity to hurl more verbal abuse at the redcoats, but happily, the soldiers ignored them and continued on their way. It was a victory for cooperation.

Although there was still a lack of trust. Once the bridge was down, Felt had accompanied Leslie across and back. As Leslie was leaving, he asked Felt, "Why have you stuck to me so closely?" Felt answered, "Had your men fired 'twas my purpose to have immediately seized and sprung with you into the channel, for I would willingly have drowned myself to have been the death of an Englishman."[8]

Tradition says Leslie's Sixty-fourth Foot played "The Old Woman Taught Wisdom" on their retreat across North Bridge. This would make sense, given

the circumstances. The song is about an old woman, Goody Bull (England), who is fighting with her daughter (America). A man enters the story:

> *I am come to make peace in this desperate fray.*
> *Derry down, down, hey derry down,*
> *I am come to make peace in this desperate fray.*
>
> *Alas, cries the old woman, And must I comply?*
> *I'd rather submit than the hussy should die.*
>
> *Pooh, prithee, be quiet, be friends and agree,*
> *You must surely be right if you're guided by me,*
>
> *Derry down, down, hey derry down,*
> *You must surely be right if you're guided by me.*

The spirit of being friends and agreeing did not seem to extend to the American side. Few recognized this as "Leslie's Truly Clever Compromise." Although this piece from the *Massachusetts Spy* of March 2, 1775, is interesting:

> *Caesar, though celebrated for an heroic mind, was liable to be betrayed by the villainous toad-eaters at his table, into low freaks; in the prosecution of which he would sometimes disgrace even his most worthy officers—for such undoubtedly was Caius Lessala. This brave, sensible, polite man, was dispatched from Castellinum…(at night) on the 5th of the Kalends of March (answering to our 25th of February) with near 300 picked men in a galley under verbal orders to land at Marmoreum, and proceed to Saleminum while the inhabitants of both places were engaged in celebrating a solemn institution. Lessala conducted the affair with a dispatch and propriety worthy of his character, expecting to find he had been sent to surprise one of Pompey's fortified magazines. But great indeed was his chagrin when he read that his errand was only to rob a private enclosure in the North-Fields of that village. He suddenly returned to Castellinum, mentioned some obstruction of a Fly-Bridge, and with not a little resentment in his eyes told Ceasar that the "geese were flown."*

In an example of what today we would call "spin," the colonists named this incident "Leslie's Retreat." And so it is known to this day.

The Myrmidons of Colonel Leslie

> **COUNTRY NEWS.**
>
> *Bath, April* 19. On Monday last the Duke of Cumberland honoured Mr. Wade with his presence at the ball at the new rooms; we are informed her Royal Highness's indisposition prevented her appearing in public that night; his Royal Highness danced two minuets; the first with Lady Boynton, the second with Lady Hope.
>
> This day the corporation of this city paid their respects in form to the Duke and Dutchess of Cumberland, and were graciously received.
>
> A Gentleman who came to Bath this day from Bristol, brings an account of the arrival of a ship from America; and it is reported the Americans have hoisted their standard of liberty at Salem, and that a great number of men in arms are daily flocking to it; and that an express is gone to London with this news. The above Gentleman says, he has seen a letter from an officer in the American militia, who intimates they only waited to hear the effect of their continental petition and remonstrance; and that, if their prayer was not granted, they were determined to stand forth and defend their liberty, or lose their lives.
>
> *Hereford, April* 20. At Brecon assizes last week Charles Crugenton, for a highway robbery, received sentence of death.

"The Americans have hoisted their standard of liberty at Salem…"

In Britain, the press reported this event as the beginning of the American Revolution. For example, the *Gentleman's Magazine* wrote, "The Americans have hoisted their standard of liberty at Salem." The Battle of Lexington and Concord had yet to happen.

So if the British at the time considered this the beginning of the American Revolution, why don't we now? The incident at Salem's North Bridge has all the dramatic elements. There's a rider from Boston who warns the locals. A scramble to get minutemen out to prevent the redcoats' objective. A confrontation. All that's missing is combat.

Remembering the Battle of Lexington and Concord honors the first blood shed in the Revolutionaries' cause. Quite a lot of blood, actually: 8 Americans and 293 British soldiers were killed. It's worth noting that Colonel Leslie was

not involved in this battle. One has to wonder if his presence might have led to a different resolution.[9]

Some tales ran that, in consequence of this defeat, Leslie was dishonored, demoted or even court-martialed. Actually, he went on to become the British general in charge of the southern theater after Cornwallis surrendered at Yorktown. Not only that, he was well respected by practically everyone. Cornwallis would later say of Leslie in his dispatches, "I have been particularly indebted to Major General Leslie for his gallantry and exertion, as well as his assistance in every other part of the service." When he died in 1794 at the age of sixty-three, he was second in command of all the forces in Scotland.

A Country Called Salem

Some native merchant of the East, they say,
(Whether Canton, Calcutta, or Bombay),
Had in his counting-room a map, whereon
Across the field in capitals was drawn
The name of Salem, meant to represent
That Salem was the Western Continent,
While in an upper corner was put down
A dot named Boston, **Salem's** *leading town.*
—*C.T. Brooks*

Salem was as familiar a name to the cannibals of the Fiji Islands, during the first half of the present century, as it was to the savages of Africa and Madagascar. In many of those wild countries, the untutored natives thought Salem comprised all the remainder of the outer world about which they knew so little.[10]

It might be difficult to believe now, but at one time Salem "was looked upon as the name of a nation," with New York, Boston and even the United States being simply ports within Salem's bounds. Right from the settlement's beginning, Salem ships went in search of trading partners. William Cash plied the transatlantic routes in his brigantine *Good Intent* before settling in Salem in 1667. A few years later, he brought over his nephew, who nine generations later produced music legend Johnny Cash.

During the Revolution, Salem alone sent out 158 armed vessels, carrying in total more than two thousand guns. They took 445 prizes and only lost 54

Andrew-Safford Place. *Courtesy of Library of Congress, HABS MASS,5-SAL,9-4.*

of their own. One of the most daring Salem privateers was Captain Jonathan Haraden of the ship *General Pickering*. With fourteen guns, he was able to resist an attack by a twenty-gun British cutter on May 29, 1780. In the Bay of Biscay, he approached a British ship with twenty-two guns and, obscured by night, announced that if it didn't surrender he would sink it. His bluff worked. The British captain, once he saw the size of the ship he had surrendered to, "was mortified to think he had submitted to such inferior force."

Off Bilboa, the *General Pickering* was approached by the British *Achilles*, which possessed forty-two guns. Captain Haraden said, "I shan't run from her." After three hours of fighting, the *Achilles* retreated. One of the men who took part in the action said of Haraden, "The shot flew around him in thousands, he was all the while as calm and steady as amidst a shower of snowflakes."

Haraden went on to capture one thousand cannon in total from British ships. He was thus described:

> *In his person, he was tall and comely…his manners and deportment mild. His discipline on board ship was excellent, especially in time of action. Yet*

> *in the common concerns of life he was easy almost to a fault. So great was the confidence he inspired that if he but looked at a sail through his glass, and then told the helmsman to steer for her, the observation went round, "If she is an enemy, she is ours."*[11]

During one of his last voyages in the *General Pickering*, Haraden attacked a heavily armed British mail packet. They fought for four hours until both were badly damaged. Haraden was down to his last powder charge. The logical thing to do would be to call a draw and go on his way. But that wasn't Haraden's style. He decided to bluff.

> *Ramming home his last charge of powder and double shotting the gun, he again ranged alongside his plucky enemy, who was terribly cut up but still unconquered and hailed her:*
>
> *"I will give you five minutes to haul down your colors. If they are not down at the end of that time I will fire into and sink you, so help me God."*
>
> *...Captain Haraden stood, watch in hand, calling off the minutes so that his voice could be heard aboard the packet:*
>
> *"One—"*
>
> *"Two—"*
>
> *"Three—"*
>
> *But he had not said "Four" when the British colors fluttered down from the yard and the packet ship was his.*[12]

One might think with all this mad daring Haraden was sure to be killed in battle some day, one of his bluffs finally going awry. Not so. He died of natural causes in Salem on November 23, 1803, at the age of fifty-nine.

After the Revolution, Salem became one of the new United States' most influential ports. In October 1798, Salem merchants joined together to raise the money to build a thirty-two-gun frigate and give it as a gift to the fledgling United States Navy. Of course, this philanthropy also meant the U.S. Navy would now have a ship to help protect Salem's West India trade from being attacked by the French. Built of white oak, the frigate launched before a cheering crowd of thousands on September 30, 1799. It was named the *Essex*.[13]

The *Essex*, not unlike the song made famous by Johnny Cash, went everywhere. It protected U.S. commerce in the Indian Ocean. It fought the Barbary pirates in the Mediterranean. During the War of 1812, it captured

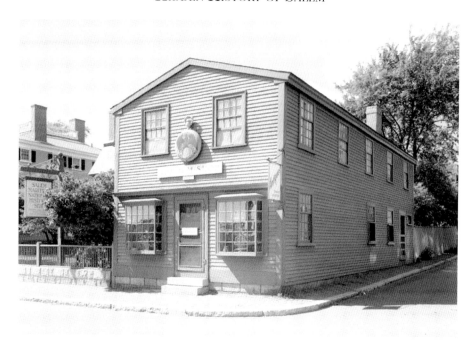

Above: The Rum Shop. Today called the West India Goods Store, where you can purchase the same goods as citizens of nineteenth-century Salem. But why is the rum gone? *Courtesy of Library of Congress, HABS MASS,5-SAL,52-1.*

Left: The China coin motif said to be unique to Salem architecture. Inspired by Salem's exploration of the East.

prizes from Bermuda to Newfoundland, and it engaged the British[14] in both the South Atlantic and the South Pacific. It was the first U.S. Navy warship to sail around both the Cape of Good Hope and Cape Horn.

The *Essex* caused so much damage that the British frigate *Phoebe* was sent to the Pacific specifically to hunt down the *Essex*. It, along with the British sloop *Cherub*, cornered the *Essex* at the neutral port of Valparaiso, Chile. Their long-range guns pummeled the *Essex*, whose carronades were more fitted to short-range attacks. After a heroic two-and-a-half-hour resistance, the *Essex* was captured March 28, 1814.

It was through commercial trading ships that Salem really came into its own. The first American vessel to pass through the Straits of Magellan and the first American ship to round the Cape of Good Hope were both from Salem. Salem ships were the first American vessels to trade with:

Batavia (Jakarta)—The Salem brig *Sally* opened American trade with Batavia in 1796.

Calcutta—The Derby ship *Atlantic* opened both Bombay and Calcutta in about 1788. Sailing between Salem and Calcutta "with the regularity of a shuttle" was the ship *George*, known on the ocean as the "Salem Frigate." Launched in 1814, it was fast and profitable, paying $651,744 in duties over twenty-one voyages.

Canton—The *Astrea*, a Derby ship, was the first to make a direct voyage to Canton in 1789.

Fiji Islands—Salem bark *Active*, captained by William P. Richardson, first opened trade with the Fiji Islands in 1811.

Japan—In 1801, the Salem ship *Margaret* went to Japan, half a century before the country was opened to commerce by Commodore Perry.[15]

Madagascar—The Salem brig *Beulah* opened Madagascar to American trade in 1821.

Manila—The Derby ship *Astrea* was the first American ship to enter Manila in the Philippines in 1796. Salem mathematician and navigator Nathaniel Bowditch was on board.

Mocha—Opened to trade in 1798 by Joseph Ropes's *Recovery*, the ship *Franklin* in 1808 carried to Salem a cargo of 532,365 pounds of coffee, on which duties of $26,618.25 were paid.

New Holland (Australia)—Australian trade commenced in 1832 thanks to the Salem ship *Tybee*, Charles Millett, master, at Sydney. *Tybee* was the first American vessel to enter an Australian port.

New Zealand—The Salem bark *Active* opened American trade with New Zealand on the same voyage as Fiji.

Russia—The Salem bark *Light Horse*, a Derby vessel, was first to go to St. Petersburg in 1784.

Sumatra—The Salem schooner *Rajah* was the first to reach Sumatra in 1793.

Zanzibar—Salem opened Zanzibar to American trade in 1825. Between 1832 and 1834, half the foreign ships entering Zanzibar sailed from Salem.

Salem also traded with Surinam, Cayenne and other South American ports, as well as Senegal and the west coast of Africa.

But Salem's greatest achievement was cornering the pepper market. From 1797 until 1805 or so, the world received the majority of its pepper reshipped from the port of Salem. Yes, the *world*. You wanted pepper? It came from Salem. Salem was even referred to as the "pepper port."

How did Salem manage this pepper monopoly? In November 1795, the schooner *Rajah* was sent on a secret expedition to find the source of wild pepper Captain Jonathan Carnes had heard tales about while in Sumatra in 1793. The *Rajah* returned a year and a half later loaded with pepper.

Pepper was considered a meat preservative as well as a flavoring, and in the days before reliable refrigeration, finding a stash of pepper was like finding gold. The owners of the *Rajah* made a profit of 700 percent. This was because they had discovered a source of pepper heretofore unknown, a source where they could purchase direct from the natives instead of going through a European wholesaler. Not wishing to lose their economic advantage, where this source was located they kept a profound secret.

A Country Called Salem

Detail of Newel Post in Derby House. *Courtesy of Library of Congress, HABS MASS,5-SAL,30-8.*

The *Rajah* was able to make two more trips before another captain discovered the secret pepper lair. Captain Joseph Ropes of the *Recovery*, who opened the American trade in coffee with Mocha in 1798, found the headquarters of the pepper supply and brought a cargo to Salem in November 1802.

Now that Salem merchants weren't purchasing from middlemen, profits skyrocketed. It should come as no surprise, then, that in 1800 Salem was America's richest city per capita. And Salem's richest man was Elias Hasket Derby.

Born in Salem on August 16, 1739, Mr. Derby alone, according to Osgood and Batchelder's *Historical Sketches of Salem*, caused 125 voyages to be made in fourteen years (1785–99) by thirty-seven different vessels, 45 of these voyages being to the East Indies or China. He was a keen businessman in an age without professional banks and financing. But apparently he was not a hard man.

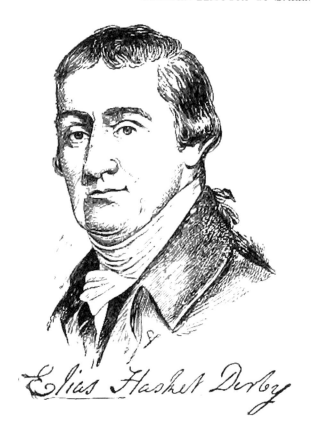

Elias Hasket Derby. Tall and dignified, he was considered a "fine figure" of a man with an affable temperament. He had one blue eye and one brown eye.

Mr. Derby sold a country clergyman a piece of broadcloth on credit, and after two or three years he sent his clerks several times for the pay, but they returned empty-handed. Mr. Derby told them they did not understand their business, and added, "Let me see him if he ever comes here again, and I will show you what can be done." The clergyman came, the clerks ushered him into the inner room, and awaited the result. They were not a little amused to see him walk out after an hour's conversation with Mr. Derby, without squaring the amount, with another piece of broadcloth under his arm.

Derby seemed to have loved his wife, Elizabeth Crowninshield, very much, despite the political nature of their marriage. He gave her large amounts of cash to spend on whatever she saw fit and, in an age when large purchases were often run by the husband first, gave shop owners standing orders to give her anything she wanted. He liked to spend Saturdays on his farm, but

A Country Called Salem

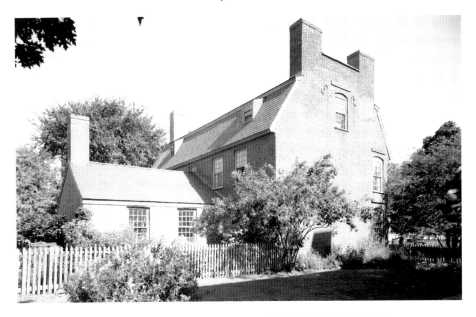

Garden of Derby House. *Courtesy Library of Congress, HABS MASS,5-SAL,30-5.*

she liked elegant mansions, so he built her one after another. The grandest of all was located on the site now occupied by Derby Square. The grounds were laid out in walks and gardens that extended all the way from Essex Street to a terrace overhanging the South River.

Elias Hasket Derby's most famous ship is probably the *Grand Turk*,[16] three hundred tons and carrying twenty-two guns, which retired from privateering to embark on the first American voyage to the Cape of Good Hope in 1781. On the way home, Captain Jonathan Ingersoll rescued two men bobbing in the ocean in a little boat. It turned out they were the captain and mate of an English schooner, the *Amity*, whose very un-amicable crew had mutinied and cast them adrift. Captain Ingersoll brought the two to Salem.

Not only had the *Amity*'s captain and mate had the good fortune to be found when they were, but they also had the good sense to stay in Salem, because, remember, Salem was one of America's main ports, and not unlike Rick's, everybody comes to Salem.

So the captain of the *Amity* was sitting with Elias Hasket Derby in his counting room, from which Derby could watch the harbor with his spyglass, and saw his own ship, the *Amity*, entering the bay. Derby immediately put two guns on board one of his brigs and gave the captain the pleasure of recapturing his ship.

Original home of Elias Hasket and Elizabeth Crowninshield Derby. They sold their "little brick house" in 1796.

Derby traded in many commodities, but the one commerce he vigorously opposed was slaving. When purchasing a cargo of slaves was suggested to him, he said he "would rather sink the whole capital employed than directly or indirectly be concerned in so infamous a trade." Not all Salem men were so enlightened.

By the time he died in 1799 at the age of sixty, his vast ship holdings and wealth had earned him the nickname "King" Derby. He left an estate exceeding $1 million. He was America's first millionaire.

> *A Salem boy in those days was born to the music of windlass chanty and caulker's maul; he drew in a taste for the sea with his mother's milk; wharves and shipyards were his playground; he shipped as boy on a coaster in his early teens, saw Demerara and St. Petersburg before he set foot in Boston, and if he had the right stuff in him, commanded an East-Indiaman before he was twenty-five.*[17]
>
> *The ports are not few where the flag of the Union, then an unknown ensign, was first displayed at the peak of a Salem ship. The country owes us a debt*

A Country Called Salem

The customhouse. Nathaniel Hawthorne worked here. *Patrick Stanbro, www.patrickstanbro.com.*

for all this which has not been grudgingly confessed. For half a century Salem maintained a leadership in American commerce which the country felt happy to admit. But water is an unstable element to which to commit a record. Our history is written on the ocean. There are no battlefields to visit. There are no monumental shafts, hung with memorial wreaths, where our bravest slumber. There are no pomps and obsequies to keep their memory green.

*The spirits of our fathers
Shall start from every wave!
For the deck,—it was their field of fame,—
And ocean was their grave!*[18]

In being the first to carry the American flag to so many foreign ports, Salem captains became very attached to the symbol. Friends presented Salem Captain William Driver with a flag they had made for him in 1824. Upon accepting it, he referred to the flag as "Old Glory."

Driver flew this flag[19] on his ship and it went twice around the world. It was flying from his brig *Charles Doggett* in 1831 when he rescued the mutineers of the British ship *Bounty* and brought them to their home on Pitcairn Island.

Captain Driver later moved to Nashville, Tennessee. He was a known Union sympathizer when the Civil War broke out, and everyone wanted to get their hands on his flag—having seen it fly from his window on patriotic occasions—for the symbolic value of destroying it. However, they searched his house and grounds in vain. Driver hid Old Glory by quilting it inside the coverlet of his bed so that the Confederates could not take it from him.

Union troops captured Nashville on February 25, 1862, and ran their small flag up the statehouse flagpole. Driver wrote of what happened next: "The Ohio 6th, the first to land, hoisted their small, beautiful flag on the State House. About an hour after, I carried my flag, 'Old Glory,' as we have

The United States flag—"Old Glory." *Courtesy of Library of Congress, LC-USZC4-7792.*

been used to call it, to the Capitol, presented it to the Ohio 6th and hoisted it with my own hands on the Capitol."

Driver gave the Ohio Regiment a flag to take with them to fly over Montgomery, Alabama, the Gulf and "every Cotton State Capital." There is some debate as to whether this flag was Old Glory or another flag he had hidden inside his comforter with it, because Driver still had Old Glory in 1883, when he presented it to his niece. Perhaps the Ohio Sixth got it back to him after the war. She gave it to the Essex Institute, and now Old Glory rests in the Smithsonian.

Whenever he sent letters to newspapers, which was one way newspapers received their news to print, he referred to his flag by name, so much so that the press started calling him "Old Glory Driver." And Driver's pet name for his flag stuck in the public mind, not just as the name of his particular flag but as a nickname for the United States flag in general.

Fallen Angel

With the talents of an angel, he became a devil.
—A Biographical Sketch of the Celebrated Salem Murderer

If, instead of charging Salem with dullness, Mr. James had accused it of brilliant wickedness, he would have come nearer the mark…Imagine a community in which abound young men, rich, well educated, having free run whether for business or pleasure among all the savage tribes and oriental nations of the world, and you see that they must quickly become eminent saints or conspicuous sinners, and so they did.
—Reverend George Batchelor on early nineteenth-century Salem

Tall, dark and handsome, Richard Crowninshield Jr. wore the title of conspicuous sinner with pride. Every man of his generation either feared him or wanted to be him. Women just wanted him. Period. Even his enemies admitted there was something about him "that carried with it an awe not easily to be overcome."

Fearless and daring, he was leader to a gang that trafficked in everything from jewel heists to body snatching. Their secret cave in Wenham Woods was described as the scene of debauched parties, complete with vast amounts of alcohol and wanton women. One might imagine it as *Robin Hood* directed by Ken Russell.

Richard's romantic escapades were tinged with danger as well. Contrary to typical male behavior of the day, he seduced women in his own social class. No taking advantage of servants or financial dependents for him. It was whispered that his sudden trip to South Carolina had been the result

Fallen Angel

of having to get out of town after ruining the reputation of a rich neighbor's daughter. Once in Charleston, he had successfully seduced that city's most beautiful southern belle.

An independent machinist by day, he ran a gambling hell in Salem on the side. Students from Harvard gravitated to this club, and it was the place to be for young men of the North Shore looking for cool society, hot women and games of chance. Richard was *the* criminal element in Salem, and everybody knew it. This was 1830, and Richard Crowninshield was twenty-five years old.

Richard Crowninshield Jr. *Sketch by EJ, imaliea. deviantart.com.*

With such a reputation, one might expect him to be in and out of jail repeatedly. He wasn't. Yes, there was a hint of scandal from a visit to New York with his younger brother George—murmurings of money stolen from a hotel—but as it had been returned, no charges were brought.

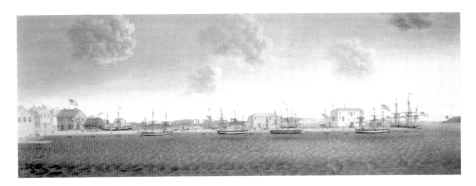

Crowninshield's Wharf, 1806. Oil on canvas. George Ropes (1788–1819). *Courtesy of the Peabody Essex Museum, Salem, Massachusetts, M3459.*

Perhaps his family name kept him free? The Crowninshield family was one of the most influential in Salem. Rising from captaining ships for the great Derby merchant family, George Crowninshield Sr. had married King Derby's sister on the way to building his own shipping empire. His was one of the busiest, and longest, wharves in Salem Harbor.

George Jr.[20] followed in his father's footsteps, commanding ships until about 1800, when he left the sea to help manage the family business. They made great profits from their privateers during the War of 1812. Even though retired from seafaring, George Jr. loved adventure. Three times he saved men from drowning, one of these rescues earning him a gold medal from the Massachusetts Humane Society. He was also a volunteer fireman.

George Jr.'s personal hobby was yachts. He built the first American yacht, named it *Jefferson* and used it to aid ships in distress along the Salem coastline. His larger yacht, *Cleopatra's Barge*,[21] became the first American yacht to cross the Atlantic in 1817.[22]

Jacob Crowninshield. *Courtesy of Library of Congress, LC-USZ6-209.*

Fallen Angel

Jacob, George Sr.'s second son, captained ships as well. In April 1796 on the armed ship *America*, he brought the first live elephant to the United States. Then his career diverged into politics. Jacob Crowninshield was elected to the Massachusetts State Senate in 1801. In 1802, he was elected to the House of Representatives and served in the Eighth, Ninth and Tenth U.S.

"United we stand, divided we fall."
Politics in Salem.
Courtesy of Library of Congress, rbpe 04702600.

George Crowninshield Jr. sending white Sumatra pepper to the president. *Courtesy of Library of Congress, mjm 14_0003_0004.*

Congresses. And, although he never assumed the duties, he was secretary of the navy from March 3, 1805, to March 7, 1809.

His younger brother Benjamin also went into politics, becoming secretary of the navy in his turn and, in 1830, a U.S. congressman. The Crowninshields were friends of the president of the United States. They were the first citizens of Salem. In 1802, when Jacob Crowninshield had been elected over Timothy Pickering, the *Gazette* printed, "It is now proved, we confess, that 'our family' [the Crowninshields] can do what they please in this town." As his father was George Sr.'s fifth son, Richard was nephew to these influential men.

Salem was a grand port in these days, equal to Boston and more important than New York. Although Richard Sr. never seemed able to make a profit, other men earned vast fortunes as shipping merchants in the East India trade. One of these men was Captain Joseph White.

Three stories high and still considered to be one of the best examples of Adamesque Federal architecture in the United States, Captain White's home was a tribute to his wealth—from the white balustrade encircling the

roof, to the ornate semicircular portico with its Corinthian columns standing sentinel at the front door, to the intricate wood-carving and lavish decoration of the interior.

It must be acknowledged that some of this wealth came from the slave trade. Although such was not uncommon in this era, it was illegal in Massachusetts. In 1788, minister Dr. Bentley wrote in his diary of his disquiet that Captain White, one of his parishioners, "confesses he has no reluctance in selling any part of the human race."

Now in 1830, having attained the age of eighty-two, with his wife and many of his relatives deceased, Joseph White probably hoped to live peacefully off the fruits of his success. He may have known that a few of his in-laws were impatient for their inheritance. But he would have known little and cared less about Richard Crowninshield and his younger brother George.

With less than two years between them, George seemed to have followed his older brother like a shadow as they were growing up. Richard got himself expelled from several schools—generally for pranks such as sneaking a cow into the headmaster's library—and George went from school to school with him. Also like a shadow, he does not seem to have left any impression. His teachers did not only remember Richard, but they also remembered him as needing to be whipped often. Nobody seems to have ever laid a hand on George. Perhaps Richard made certain of it. His japes would have required confederates, but despite intense punishments, he never named names.

He kept George clear of beatings at home, too. Their own father, an interesting but flawed (and dreadfully unlucky) man, possessed a short, violent temper. He beat their eldest, mentally challenged[23] brother. Richard kept George out of his father's way.

With his dangerous reputation established early, no one dared to cross Richard, which meant that George was safe within his brother's shadow even once they were adults. Richard solidified his position as the "terror of Essex County" while George dabbled with scarlet women and made some unsavory friends. Unfortunately for them, being Salem's incipient most wanted meant that when Captain White was found dead in his own bed on April 6, gruesomely murdered, no one questioned whom the prime suspect ought to be. Even Richard's own extended family, such as his cousin Sally, wondered if he would be found "to have a hand in it."

The Salem newspapers reported all of the crime's gory details. White had been both bludgeoned and stabbed. Someone had slipped into White's mansion, climbed the stairs to his bedroom, bashed his skull, stabbed him

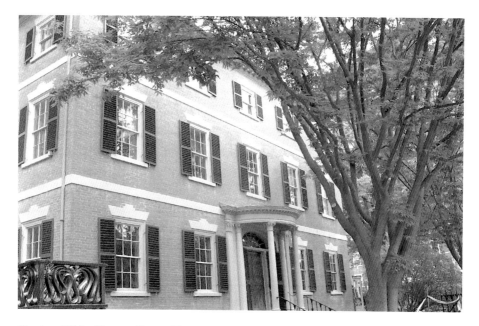

Gardner-White-Pingree House. The murder occurred on the second floor, left bedroom (nearest the camera).

thirteen times, tucked his body back under the sheets and slipped out. Nothing from his house had been stolen but his life. It was as if the murder had been committed solely for the fun of it. That just had to be Richard Crowninshield Jr., right?

On May 2, Richard Crowninshield Jr., his younger brother George and their friends Benjamin Selman and Daniel Chase were arrested for murder. Selman and Chase were from Marblehead, and that city was indignant when all four were indicted on May 5 by a grand jury that had been told there was a "mass of evidence" against the young men but never shown any of it. Selman and Chase spent three months in jail before finally being discharged.

Notorious for his external indifference to his plight, his stoicism and cool composure, Richard turned twenty-six years old in jail while the Committee of Vigilance attempted to find more than rumors with which to prosecute him. His sister Sarah sent him a rose. Through her, he was able to obtain books, asking for subjects from mathematics and mechanics to Irish[24] melodies. In true Byronic form, he also wrote poetry, including a poem for his sister to thank her for the rose.[25]

Meanwhile, a blackmailer named John Palmer came to the committee's attention. He had unusual knowledge of the murder and, once detained,

declared amongst protestations of innocence that he had simply overheard the plan being made between the Crowninshields and two of Captain White's in-laws, brothers Joseph and Frank Knapp. This was the break the committee had been waiting for. The Knapps were arrested. Unlike most of the Crowninshields, their family did not abandon them, and they had many visitors.

When Reverend Henry Colman, the man who had performed Joseph's marriage to Captain White's grandniece, visited Joseph in his cell, Joseph probably assumed he came in friendship. He forgot that Colman was Captain White's friend as well. Colman urged Joseph to confess, reminding him of how difficult life would be for his pretty wife if he died and promising immunity if he would tell all.

Colman did not actually have the power to grant judicial immunity, so when it looked like Joseph was seriously considering his offer, he had to rush to the attorney general. Colman returned to the Salem jail with "a letter from the Attorney General offering to *any one of the prisoners except Richard Crowninshield* the privilege of being State's witness" (emphasis mine). Now that they had Richard in jail, the state would never let him out.

Frank Knapp and George Crowninshield were stalwart in their declarations of innocence, so Colman continued to hammer Joseph. He was the only married man among the accused. That dependent proved to be his weakness.

Joseph decided, for the sake of his wife, to take Colman up on the offer—but only if his younger brother Frank was okay with it. Colman rushed over to Frank's cell, explained the situation—how Joseph would live if he sold out his brother and the Crowninshields—and asked Frank if he would consent to it. Frank replied, "I don't see that it is left for me to choose. I must consent."

Thus, on May 29, with the promise of immunity, Joseph Knapp confessed to planning the crime and named Richard as the murderer. He also implicated his own brother Frank as having accompanied Richard to the street outside White's mansion and Richard's brother George as having known of the crime in its planning stage. Upon being informed of this development in his cell in the Salem jail, Richard is said to have responded: "I only wish I was in reach of him [Joseph] one minute." "What would you do?" He smiled with a singular and almost terrific expression of countenance and replied, "Not much, not much."

The bad news kept coming. On June 13, a bale of stolen flannels was discovered in the Crowninshield barn. Remembering that the Crowninshields had been in jail since May 2 and the barn had been searched in May, you

might wonder how the goods, stolen back on March 1, suddenly materialized where they would add the most weight to the prosecution's contention that the Crowninshield brothers were villains. Or maybe you wouldn't wonder that hard, after all.

Richard certainly wasn't wondering. He knew they were dead.

Franklin Dexter of Boston had been retained as chief counsel for the defense. On one of his visits to his imprisoned clients, Richard asked him—several times—to explain Massachusetts law concerning principals and accessories. At this time, a principal perpetrator had to be convicted first before anyone could be tried as an accessory. If no principal were convicted, no accessory could be brought to trial.

Richard knew he was the sole principal accused. All the rest were charged with being accessories. Dexter took his detailed questioning to indicate that Richard was indeed guilty of being the principal perpetrator in White's murder. What other motive could there be?

Early in the afternoon of June 15, Richard asked Nehemiah Brown, the keeper of the Salem jail, for a straight razor with which to shave. Mission accomplished, he returned the blade. He folded his clothes and carefully arranged all his possessions on his narrow cell cot. Then he knotted together two silk handkerchiefs.

Around 2:00 p.m., Brown walked by the cells and called to Richard. He received no answer. Peering through the cell door's wicket, Brown discovered Richard hanging from the grating in the wall, the handkerchief rope twisted about his neck. Too tall within the confines of the cell to actually hang, he had been forced to crouch, bended knees not a foot from the floor, in order to achieve his own strangulation.

Quickly cutting him down with the help of the turnkey, Brown called for a doctor. Richard's body was still warm. There was a chance they could recover him for the gallows. Physicians applied a galvanic battery to his chest. No response. They cut his throat to see if his blood still circulated and watched as it ceased to flow.

Richard Crowninshield Jr. was dead. He was twenty-six years old.

For suicide notes, he left two letters, one to his father and one to his brother George. The one to his father began, "Dear Father—These are the last lines from your undutiful son…" His letter to George was more emotional.

> *Dear Brother—May God and your innocence guide you safe through this trial…I have come to the determination to deprive them of the pleasure*

Fallen Angel

of beholding me publicly executed…O George forgive me for what I have caused you and others to suffer on my account. This is my last benediction to you. A long and last adieu.

He also left George a poem.

> *To George*
> *Ungrateful wretches why do ye crave*
> *The life our heavenly father gave.*
> *And why confine us in this gloomy cell*
> *Where nothing save grief and sorrow dwells.*
> *Detested friends be banished hence.*
> *Away your kindred go. Boast not your sense*
> *We're imps of hell. And devils reign. Go and seek*
> *Out your native home.*
> *From Your Brother Richard.*

The public interpreted Richard's suicide as the act of a guilty conscience, and his letters were seen as supporting documentation to this physical "confession." Not surprisingly, the story of his life became a media sensation almost overnight. It had everything, including a moral. Audiences could wallow in salacious detail and then feel uplifted as vice comes to no good in the end and death is the wage of sin.

Wax figures portraying Richard in the midst of murder, about to strike the supine body of sleeping Captain White, toured the country for years afterward. Pamphlets circulated detailing his colorful history. For the next quarter of a century, newspapers trotted out his tale any time a reference to cold-blooded murder was needed.

As his infamy spread across the United States, it even extended overseas. In *Six Thousand Illustrations of Moral and Religious Truths Alphabetically Arranged*, published in London, Richard Crowninshield is the definition under "Conscience (A Hardened)." Not many people rate being the dictionary definition of a term.

Another commentary that had wide circulation in both America and Europe appeared in 1848: Henry C. Wright's *Dick Crowninshield the Assassin and Zachary Taylor the Soldier; The Difference Between Them*, an indictment of Taylor for heavy civilian casualties during the capture of Monterrey. The character of Richard is seen as rationalizing his crime by comparing it to soldiering.

> *Dick:—Well, I see no more wrong in enlisting in the service of* two *men to kill* one, *at their bidding and for their benefit, than in enlisting into the service of* millions, *called a State, to kill* thousands *at their bidding and for their benefit. So I am at your service, and will execute your pleasure upon Joseph White.*

And in case the reader had forgotten precisely what Richard had done—this being eighteen years later, after all:

> *The Knapps furnished their recruit with a dirk and bludgeon. At midnight he entered the back window with a dark lantern, crept up the front stairs, and entered the sleeping chamber of Joseph White. He was asleep; Dick struck him on his head with a club; then turned down the clothes, and stabbed him thirteen times in the region of his heart; then covered him up, left the house, hid the bludgeon under the door steps of a church, and melted the dagger.*

Thus, his reputation as a stone cold killer was secure. But did his daring plan to save his brother's life succeed?

Actually, yes. Frank Knapp was elevated from accessory to principal, and although it took two trials to convince a jury of his guilt, his conviction paved the way for the trials of Joseph Knapp and George Crowninshield. Trial of *Joseph*, you ask? Yes, Joseph Knapp at the last moment renounced his immunity. He was found guilty as well, and both Knapp brothers were hanged.

George had alibi witnesses as to where he was at the time of the murder, and even according to the prosecution his only participation in the crime was foreknowledge. His trial was also the last, so everyone knew justice had already acquired three deaths in payment for the horrendous crime. Given such a situation, George must have known he stood a chance of escaping with his life, but he did himself no favors by attending his trial with what was seen by the public as a surprising lack of concern. In fact, he periodically interjected flippant comments during the proceedings.[26]

Some interpreted that indifferently fearless air to mean he was certain of his acquittal, and they were incensed. No one seems to have speculated that perhaps, knowing what his brother did on his behalf, he wasn't averse to joining him. In the end, his attitude failed to sabotage his case. George was found not guilty. Would he have been acquitted if Richard had gone to trial?

Fallen Angel

Daniel Webster.
Courtesy of Library
of Congress,
LC-DIG-
cwpbh-01233.

Richard's suicide threw a serious wrench in the state's prosecution of the crime. Labeling Frank a principal did not change the fact that he hadn't physically done anything to anyone. He hadn't even been present inside the house. It was the eloquence of Daniel Webster, whom the state hired to prosecute on its behalf, that convinced the jury Frank was a principal, not the evidence. So even when the desired death sentences had been won, a touch of uneasiness remained regarding the means of securing victory. This may have factored into George's not guilty verdict.

In any case, Richard's goal—that George should survive—was achieved. George Crowninshield lived to be eighty-three years old. And

MURDER OF JOSEPH WHITE.

The following lines were written on the death of Mr. Joseph White, of Salem, who was found murdered in his bed, on the morning of April 7, 1830, aged 82 years.

"Shall auld acquaintance be forgot, and never brought to mind?
Shall 'horrid murder' be forgot, in the days of Auld Lang Syne?
No! let this tale be treasured up, that young and old may know,
That they taste not the bitter cup of sin, death, and wo.

Tune, "Auld Lang Syne."

O WHAT a horrid tale to sound,
 In this our land to tell,
That JOSEPH WHITE, of Salem town,
 By ruffian hands he fell!
Perhaps for money or for gain,
 This wicked deed was done;
But if for either, great the pain
 This monster must be in.

O thou infernal of the damned,
 To murder in the night,
With cruel arm and blood-stained hand,
 Which pierced the side of WHITE;
Thou hardened-hearted monster devil,
 To thrust the dirk of death,
You will be placed upon the level,
 For time will stop your breath!

There you will lie, 'the trump will sound,'
 And God will call you forth;
You will be judged, and then be bound
 In weighty chains of wrath,
And doomed to that infernal place,
 Where devils have their train,
You must be paid by *devils' grace*,
 With torture, anguish, pain.

What led you to this awful deed,
 No man on earth can tell;
But may we know, God give it speed,
 That you may flee from hell.
O that the mighty Arm above
 Would bring to light the wretch,
And on his soul might rest the Dove
 That gave this sinner breath.

Who would have thought that such a deed,
 In this, our Christian land,
Would e'er have taken place, indeed!
 It has, O cruel hand!
To slay an aged gentleman,
 No person he could harm,
Is murder shocking, in extreme,
 While he lay sleeping calm.

Calmly he laid in sweet repose,
 The ruffian forced the room,
And with his dirk he did dispose
 Of him, who'd done no harm.
Great God, how can these things be so?
 When man is left alone,
Poor feeble wretch, he does not know
 How wicked he has done.

The restraining grace of Heaven
 Will keep us all from wrong,
But O, that cursed hellish leaven,
 It *leavens*, to be strong,
Like devils, for destruction bold,
 And wealth and blood their aim,
And to all good their hearts are cold,
 Care not for heavenly claim.

O! did you think you were concealed?
 No; no, there's ONE could see,
And sure the crime will be revealed,
 This side of eternity,
And banish him, that cursed wretch,
 Into that dark abode,
Where *devils* fight; think not of *wealth*,
 And he will join their code.

For he has been a Brutus bold,
 Without the fear of God,
To heavenly precepts he is cold,
 He thirsts for wealth and blood.
He has effected a design,
 To him will prove a curse;
He may be dropped from the *platform*,
 Or doomed to something worse.

Great Pope once said that all was 'right,'
 So said a sturdy thief;
But when he found a rope, he might
 Have altered his belief;
And so would say that artful wretch,
 Who murdered Joseph White—
The hangman he may stop his breath,
 And prove that Pope was 'right.'

Sold, Wholesale & Retail, by L. DEMING, No. 62, Hanover St. Boston, and at MIDDLEBURY, Vt.

"Murder of Joseph White." To be sung to the tune of "Auld Lang Syne." *Courtesy of Library of Congress, as109040.*

he always maintained his brother's innocence, despite public opposition to the idea. As Bradley and Winans wrote in *Daniel Webster and the Salem Murder*, "Dick's suicide was interpreted by most as conclusive proof of his guilt. Anyone who suggested that an innocent man might take his own life under such circumstances, even to assure his brother's safety, was thought very foolish indeed."

Surprising Salem

What with the immortal reputation of the witch trials, you might be forgiven for thinking the words *Salem* and *tolerance* are not often found in the same sentence. You would be wrong.

Reverend William Bentley was the pastor of Salem's Second Congregational Church, also known as the East Church. He read twenty different languages, including Arabic and Persian. In fact, the United States government sent the credentials of the Tunisian ambassador to him for translation. Bentley was a friend of President Thomas Jefferson, who tried to appoint him chaplain of the United States Congress and later the first president of the University of Virginia. He declined both honors, preferring his East Church and to perform good works around Salem. For Bentley, good works were the cornerstone of religion.

In 1790, there was no Catholic church in Salem. A Boston priest wrote to Bentley asking for help in "procuring a suitable hall" where he "might give a lecture explanatory of the rites and doctrines of his church." Dr. Bentley responded:

> *Mr Thayer, Priest.*
> *Rev. Sir.*
> *It is my desire that every man enjoy his religion not by toleration, but as the inalienable right of his nature. I communicated your letter to two of the Selectmen, and assure you of the fullest protection our internal police can give you. As to lodgings, should you call on me, I will give you all the information in my power, & we may then consult about the place of*

Surprising Salem

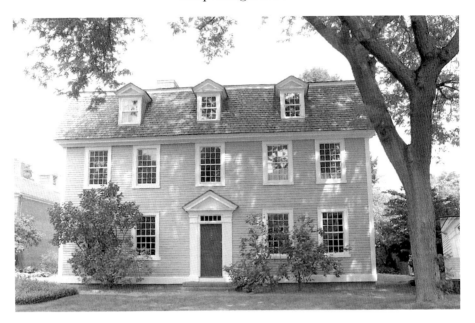

The Crowninshield-Bentley House. William Bentley boarded here from 1791 until his death in 1819.

worship. As there are several religious societies of various denominations in the Town, and the Catholics are without any outward distinction, I can only mention such are within my acquaintance, and probably only a small part, as the Catholics commonly have worshiped according to the rites & ceremonies of the English Church…You can by a conversation with them inform yourself of the whole number in the place and vicinity.
Revd Sir,
your devoted Servant,
W.B.

In the end, Bentley not only found Thayer a hall but also invited the priest to stay at his place and, as none of the Catholic citizens could afford the expense, provided for his guest for several days. Bentley wrote in his diary, Thayer's "support therefore fell upon me, and consequently all the prejudice which can arise in illiberal minds on such an occasion."

Blessed with patience and a wicked sense of humor, Dr. Bentley could give as good as he got. Another diary entry recorded that he "went to Beverly to see Rev. Oliver with Thayer as a mere amusement, and I did not fail of

success. The bigotry of Oliver joined to an honest but uninformed mind opposed to the humor and insulting triumph of a catholic could not fail of effects entertaining to one of their old acquaintance."

With Bentley's help, Thayer celebrated the first Mass in Essex County. Eventually, Salem Catholics would found St. Mary's, the first Catholic church dedicated to Mary in New England. In 1825, it became the first Catholic parish beyond Boston.

Clearly unafraid of religious competition, Bentley invited guest speakers to his Unitarian pulpit, including "Methodist, Calvinist, Presbyterian, Baptist, and Episcopalian" lecturers "of Scotch, English and African nativities." His congregation must have been open to such presentations, otherwise he would not have continued. Salemites could be surprising that way.

The Selling of Provided Southwick

Religious Society of Friends (Quaker) missionaries arrived in Salem in 1656. Their message of simplicity, harmony, truth and equality appealed to many of the colonists, especially women. In Salem, a woman who criticized town elders or magistrates ran the risk of having "a cleft stick placed on her tongue for half an hour in public." During Quaker services, women—and even young girls, who had no voice in the running of Puritan society—were encouraged to speak.

Unfortunately for them, the Puritan establishment considered Quakers heretics. You might wonder why a group of people who had been persecuted for their religious beliefs would then turn and persecute others for theirs, but from the Puritan point of view, they had suffered enough to get what they wanted, and they were not about to let their hard-won model community be polluted by unorthodox thought. The fact that Quakers refused to show proper deference to their superiors by, for example, removing their hats also drove them crazy. Honoring the hierarchy was pretty important to Puritans. The more threatened they felt, the more punishments for being a Quaker escalated—from hours in the stocks, whipping and imprisonment to banishment on pain of death.

On June 26, 1658, a gathering of Quakers in Salem was raided. Those arrested included the Southwick family, parents Lawrence and Cassandra, sons Josiah and Daniel and seventeen-year-old daughter Provided. When they were brought before the magistrates for punishment, Provided repeatedly

called the court a bunch of "persecutors" and was sent to the stocks for an hour. Then the family was sent to prison.

As repeat offenders, Lawrence, Cassandra and Josiah Southwick were eventually banished on pain of death, which meant that they would be killed if they returned. Daniel and Provided were left to fend for themselves. Still defiant, they refused to attend Puritan services. As church attendance was compulsory, they were arrested and fined.

At this time, prisoners were charged for their upkeep in prison. Thus, even if the court ordered your release, you could remain trapped in jail until you paid your bill, with more fees accruing each day. Provided and Daniel refused to pay their fines. So the court, not wanting martyrs on their hands, decided to sell them. Surely some Salem ship captain or sailor would want to purchase a pretty white slave girl. The things that might happen to her in servitude would prove more than enough of a warning to other Quaker women. As an example, it couldn't be beat. With Daniel up on the block as well, they were certain to make enough to cover their fines.

John Greenleaf Whittier wrote a poem about what happened next, although he mistakenly called Provided Cassandra (and oddly refers to the presence of a priest):

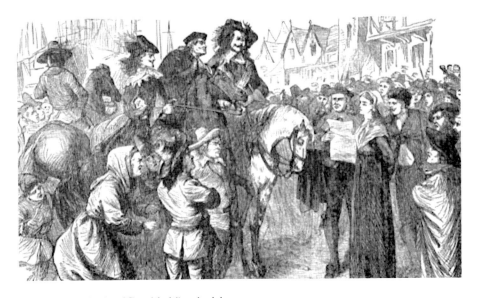

The attempted sale of Provided Southwick.

To the God of all sure mercies let my blessing rise to-day,
From the scoffer and the cruel He hath plucked the spoil away;
Yea, He who cooled the furnace around the faithful three,
And tamed the Chaldean lions, hath set His handmaid free!

Last night I saw the sunset melt through my prison bars,
Last night across my damp earth-floor fell the pale gleam of stars;
In the coldness and the darkness all through the long night-time,
My grated casement whitened with autumn's early rime.

Alone, in that dark sorrow, hour after hour crept by;
Star after star looked palely in and sank adown the sky;
No sound amid night's stillness, save that which seemed to be
The dull and heavy beating of the pulses of the sea;

All night I sat unsleeping, for I knew that on the morrow
The ruler and the cruel priest would mock me in my sorrow.
Dragged to their place of market, and bargained for and sold.
Like a lamb before the shambles, like a heifer from the fold!

Oh, the weakness of the flesh was there,—the shrinking and the shame;
And the low voice of the Tempter like whispers to me came:
"Why sit'st thou thus forlornly," the wicked murmur said,
"Damp walls thy bower of beauty, cold earth thy maiden bed?

"Where be the smiling faces, and voices soft and sweet,
Seen in thy father's dwelling, heard in the pleasant street?
Where be the youths whose glances, the summer Sabbath through,
Turned tenderly and timidly unto thy father's pew?

"Why sit'st thou here, Cassandra?—Bethink thee with what mirth
Thy happy schoolmates gather around the warm, bright hearth;
How the crimson shadows tremble on foreheads white and fair,
On eyes of merry girlhood, half hid in golden hair.

"Not for thee the hearth-fire brightens, not for thee kind words are spoken,
Not for thee the nuts of Wenham woods by laughing boys are broken;

Surprising Salem

No first-fruits of the orchard within thy lap are laid,
For thee no flowers of autumn the youthful hunters braid.

"O weak, deluded maiden!—by crazy fancies led.
With wild and raving railers an evil path to tread;
To leave a wholesome worship, and teaching pure and sound,
And mate with maniac women, loose-haired and sackcloth bound,—

"Mad scoffers of the priesthood, who mock at things divine,
Who rail against the pulpit, and holy bread and wine;
Sore from their cart-tail scourgings, and from the pillory lame.
Rejoicing in their wretchedness, and glorying in their shame.

"And what a fate awaits thee!—a sadly toiling slave.
Dragging the slowly lengthening chain of bondage to the grave!
Think of thy woman's nature, subdued in hopeless thrall,
The easy prey of any, the scoff and scorn of all!"

Oh, ever as the Tempter spoke, and feeble Nature's fears
Wrung drop by drop the scalding flow of unavailing tears,
I wrestled down the evil thoughts, and strove in silent prayer,
To feel, O Helper of the weak! that Thou indeed we'rt there!

I thought of Paul and Silas, within Philippi's cell,
And how from Peter's sleeping limbs the prison shackles fell,
Till I seemed to hear the trailing of an angel's robe of white.
And to feel a blessed presence invisible to sight.

Bless the Lord for all his mercies!—for the peace and love I felt.
Like dew of Hermon's holy hill, upon my spirit melt;
When "Get behind me, Satan!" was the language of my heart.
And I felt the Evil Tempter with all his doubts depart.

Slow broke the gray cold morning; again the sunshine fell,
Flecked with the shade of bar and grate within my lonely cell;
The hoar-frost melted on the wall, and upward from the street
Came careless laugh and idle word, and tread of passing feet.

Hidden History of Salem

At length the heavy bolts fell back, my door was open cast,
And slowly at the sheriff's side, up the long street I passed;
I heard the murmur round me, and felt, but dared not see,
How, from every door and window, the people gazed on me.

And doubt and fear fell on me, shame burned upon my cheek,
Swam earth and sky around me, my trembling limbs grew weak:
"O Lord! support thy handmaid; and from her soul cast out
The fear of man, which brings a snare, the weakness and the doubt."

Then the dreary shadows scattered, like a cloud in morning's breeze,
And a low deep voice within me seemed whispering words like these:
"Though thy earth be as the iron, and thy heaven a brazen wall,
Trust still His loving-kindness whose power is over all."

We paused at length, where at my feet the sunlit waters broke
On glaring reach of shining beach, and shingly wall of rock;
The merchant-ships lay idly there, in hard clear lines on high,
Tracing with rope and slender spar their network on the sky.

And there were ancient citizens, cloak-wrapped and grave and cold,
And grim and stout sea-captains with faces bronzed and old.
And on his horse, with Rawson, his cruel clerk at hand.
Sat dark and haughty Endicott, the ruler of the land.

And poisoning with his evil words the ruler's ready ear,
The priest leaned o'er his saddle, with laugh and scoff and jeer;
It stirred my soul, and from my lips the seal of silence broke.
As if through woman's weakness a warning spirit spoke.

I cried, "The Lord rebuke thee, thou smiter of the meek,
Thou robber of the righteous, thou trampler of the weak!
Go light the dark, cold hearth-stones,—go turn the prison lock
Of the poor hearts thou hast hunted, thou wolf amid the flock!"

Dark lowered the brows of Endicott, and with a deeper red
O'er Rawson's wine-empurpled cheek the flush of anger spread;

Surprising Salem

"Good people," quoth the white-lipped priest, "heed not her words so wild,
Her Master speaks within her,—the Devil owns his child!"

But gray heads shook, and young brows knit, the while the sheriff read
That law the wicked rulers against the poor have made,
Who to their house of Rimmon and idol priesthood bring
No bended knee of worship, nor gainful offering.

Then to the stout sea-captains the sheriff, turning, said,—
"Which of ye, worthy seamen, will take this Quaker maid?
In the Isle of fair Barbadoes, or on Virginia's shore,
You may hold her at a higher price than Indian girl or Moor."

Grim and silent stood the captains; and when again he cried,
"Speak out, my worthy seamen!"—no voice, no sign replied;
But I felt a hard hand press my own, and kind words met my ear,—
"God bless thee, and preserve thee, my gentle girl and dear!"

A weight seemed lifted from my heart, a pitying friend was nigh,—
I felt it in his hard, rough hand, and saw it in his eye;
And when again the sheriff spoke, that voice, so kind to me,
Growled back its stormy answer like the roaring of the sea,—

"Pile my ship with bars of silver, pack with coins of Spanish gold.
From keel-piece up to deck-plank, the roomage of her hold,
By the living God who made me!—I would sooner in your bay
Sink ship and crew and cargo, than bear this child away!"

"Well answered, worthy captain, shame on their cruel laws!"
Ran through the crowd in murmurs loud the people's just applause.
"Like the herdsman of Tekoa, in Israel of old,
Shall we see the poor and righteous again for silver sold?"

I looked on haughty Endicott; with weapon half-way drawn,
Swept round the throng his lion glare of bitter hate and scorn;
Fiercely he drew his bridle-rein, and turned in silence back.
And sneering priest and baffled clerk rode murmuring in his track.

Hard after them the sheriff looked, in bitterness of soul;
Thrice smote his staff upon the ground, and crushed his parchment roll,
"Good friends," he said, "since both have fled, the ruler and the priest.
Judge ye, if from their further work I be not well released."

Loud was the cheer which, full and clear, swept round the silent bay,
As, with kind words and kinder looks, he bade me go my way;
For He who turns the courses of the streamlet of the glen,
And the river of great waters, had turned the hearts of men.

Oh, at that hour the very earth seemed changed beneath my eye,
A holier wonder round me rose the blue walls of the sky,
A lovelier light on rock and hill and stream and woodland lay,
And softer lapsed on sunnier sands the waters of the bay.

Thanksgiving to the Lord of life! to Him all praises be,
Who from the hands of evil men hath set his handmaid free;
All praise to Him before whose power the mighty are afraid,
Who takes the crafty in the snare which for the poor is laid!

Sing, O my soul, rejoicingly, on evening's twilight calm
Uplift the loud thanksgiving, pour forth the grateful psalm;
Let all dear hearts with me rejoice, as did the saints of old,
When of the Lord's good angel the rescued Peter told.

And weep and howl, ye evil priests and mighty men of wrong,
The Lord shall smite the proud, and lay His hand upon the strong.
Woe to the wicked rulers in His avenging hour!
Woe to the wolves who seek the flocks to raven and devour!

But let the humble ones arise, the poor in heart be glad,
And let the mourning ones again with robes of praise be clad.
For He who cooled the furnace, and smoothed the stormy wave,
And tamed the Chaldean lions, is mighty still to save!

While the Quakers were seen as a threat to cohesive government, the public often regarded them sympathetically, especially the more secular citizens at the port of Salem. So when treasurer Edmund Butter arrived,

with the sale order from Secretary of the Court Edward Rawson in hand, he may have been surprised only that the men's concupiscence or cupidity did not outweigh their solicitude.

At one point when Butter pressed the ship captains to take Daniel and Provided, a shipmaster declined with the excuse that they would "spoil the ship's company."

Butter replied, "No, you need not fear that, for they are poor harmless creatures, and will not hurt anybody."

"Will they not so," responded the shipmaster, "and will you offer to make slaves of such harmless creatures?"

In the end, no buyers were found for Provided and Daniel. Perhaps in an attempt to bury the fiasco, the two were released.

Things would get better for the Quakers of Salem. In 1789, President George Washington visited Salem. The chairman of the selectmen who greeted him on behalf of the city, William Northey, was a Quaker. He shook Washington by the hand and said, "Friend Washington, we are glad to see thee, and in behalf of the inhabitants, bid thee a hearty welcome to Salem." Per Quaker custom, he did not remove his hat.

THE DRAGON'S LEFT FOOT

Everyone has seen this picture. Its inclusion in American history books seems practically required. Well, there Salem is—*right there*—the creature's left foot.

So what's the story behind this? In 1812, Elbridge Gerry, governor of Massachusetts, and the Democratic-Republican legislature redrew the state's electoral districts in the hope of keeping themselves in power. One of these new districts in Essex County was particularly distorted in the way it roped in some cities' voters and shut out others.

Tradition has it that an artist visiting newspaper editor Benjamin Russell drew a head, wings and claws on this twisted district and called it a salamander (meaning a mythical, dragon-like beast). The Federalist editor redubbed it a *Gerry-mander*, in honor of the governor, and the name stuck.

The Republicans didn't, however. In 1813, despite the redistricting, they lost to the Federalists. Hence the skeleton cartoon.

Was gerrymandering really dead? No, it still goes on today. But *yay* Salem for wishful thinking.

Gerrymandering, the deliberate redrawing of constituency boundaries to affect election results, started in Massachusetts. The shape of one such new district in Essex County in 1812 resembled a dragon.

In 1813, when the Federalists won despite the redistricting, the *Salem Gazette* ran this cartoon announcing "the Death of that far-famed and ill-begotten Monster, the Gerry-Mander."

Surprising Salem

Benjamin W. Crowninshield

Being a Salem Crowninshield meant accepting the duty to serve your community, and Benjamin W. Crowninshield took this responsibility seriously. After having been sent to sea and risen from cabin boy to captain, he succeeded his brother Jacob in the Massachusetts House of Representatives in 1811, became a member of the Massachusetts State Senate in 1812 and was appointed secretary of the navy in President Madison's cabinet. He took office January 16, 1815, and continued to be secretary of the navy under President Monroe until October 1818. He was elected a Massachusetts state senator in 1822 and remained so until 1831.

Out of all this service, the most surprising act of his, in my opinion, came at the beginning of his political career, when he came up against the American Board of Commissioners for Foreign Missions. The Massachusetts-grown board's purpose was to send missionaries to foreign lands. Newly formed in 1810, it petitioned the state to allow it to incorporate, knowing it would be easier to transact business that way. This put it up against Benjamin W. Crowninshield in 1811.

Benjamin W. "ridiculed" the idea and "said that all efforts of that kind would be worse than vain." The Massachusetts House agreed with him, but only by nineteen votes. The following year, the new House voted in favor of incorporation. Benjamin W. was now in the Massachusetts State Senate, so he set about convincing the Senate to join his opposition.

Objecting from the floor of the Senate, Benjamin W. defended the right of the Hindus to be free from interference in their beliefs. "Professing to speak from personal knowledge of missions in the East, he represented the conduct of missionaries there as unworthy, and their labors as worse than useless…The project of sending money out of the country for their support, when it was so much needed for religion at home, was to be reprobated."

Benjamin W. is traditionally quoted as saying he opposed the incorporation of the American Board of Commissioners for Foreign Missions because its purpose was "to export religion, whereas there is none to spare from among ourselves."

Judge Daniel White of Salem countered him by saying that "religion is a commodity of which the more we export, the more we have remaining." The Senate agreed with Crowninshield, however, and the incorporation was voted down.

But the House did not wish to give up. After multiple committees and conferences, eventually a compromise was reached. The American Board of

Commissioners for Foreign Missions was granted its incorporation in 1812. Crowninshield family friend and minister Dr. Bentley said that "he hoped if the people of our country carry our religion to the Hindus, they will bring back the morality of India."

With regard to India, Benjamin W. is not the only surprising Benjamin of the Crowninshield family. It is from Benjamin Crowninshield, Benjamin W.'s cousin, that we get one of the earliest and most unbiased descriptions of the practice of suttee (*sati*), the ritual suicide of a wife upon her dead husband's funeral pyre. On November 28, 1789, he witnessed such an event in Calcutta.

He describes how the widow "laid herself down alongside of her husband with her right hand under his neck, his right arm over hers, his right leg over her." The corpse had been out two days and "smelt disagreeably," by the way. Then her two young sons came forward, and one, whom Crowninshield reckoned six years old, "set fire to the pile towards her head," while her four-year-old son set fire "towards her feet." He concluded his account by writing of the wife, "I did not think it was in the power of a human person to meet death in such a manner."

For comparison, another account of a suttee in Calcutta from 1810 details many of the same preparations, including her young child being given the torch to light the pyre. But this author interjects comments like, "I scarcely know how to paint in colours that shall not disgust and shock your readers, the horrible close of the scene," and, "A kind of incredulous horror at what was passing had till now riveted us to the spot, but the scene became too shocking, and we quickly retired."

Of course, while historians appreciate an unbiased narrative, perhaps a little emotion is not inappropriate when witnessing a woman being burned alive.

Joseph Smith

For there are more treasures than one for you in this city.
—*the Salem Prophecy*

Mormon founder Joseph Smith received a revelation in Salem August 6, 1836. He had been hunting for an earthly treasure said to have been secretly buried in the basement of a Salem house to help with his movement's increasing bills but instead received the prophecy that Salem would be given "into your hands, that you shall have power over it."

Surprising Salem

This was not Smith's first trip to Salem. He had spent time as a boy here, recuperating from a bone infection in his leg that normally would have required amputation. Convalescing by the seaside was a common prescription in nineteenth-century Britain and America, and in this case perhaps Salem sea air did him some good.

Joseph Smith did not preach in Salem, but Sidney Rigdon did. He gave a lecture on what the *Essex Register* titled "Mormonism" at the Salem Lyceum, and many curious citizens attended, including the *Register* reporter. He described Rigdon: "The preacher was a man of very respectable appearance, apparently about 40 years of age, and very fluent in his language."

Most places were not as tolerant as Salem. The *Boston Daily Times* referred to the visiting Mormons as a "tribe of imposters."

A Church of Latter-Day Saints was formed in Salem in 1842 but dissolved in 1844 when the congregation moved to Nauvoo, Illinois.

CHARLOTTE FORTEN

Charlotte Forten was a rich Philadelphia man's daughter. Her family's fortune came from its sail-making business, and as it had been long established by the time she was growing up, she enjoyed all the social comforts a Victorian lady could expect. She was not expected to simply be an ornament for the home, however. Her father wanted her to get a good education.

He had educated Charlotte at home until she was sixteen. Now he wanted to send her off to school. Unfortunately, he couldn't be certain of the quality of the education she would receive there. Philadelphia schools were segregated, and Charlotte Forten was black.

So in 1853, Charlotte's father sent her to Salem to finish her schooling. Salem's public schools were not segregated, thanks to the agitation of Salem's successful African American community.[27] One of the leading members of this community was Charles Lenox Remond. Charlotte stayed with him and his family.

Remond was born in Salem in 1810. He quickly gained a reputation as an abolitionist speaker and became one of the first African Americans hired to travel the country as a professional orator to inform white audiences on the subject. He was an agent of the New England Anti-Slavery Society, a delegate of the American Anti-Slavery Society and a member of the World Anti-Slavery Conference in London in 1840.[28]

Charles Lenox Remond.

In 1842, Charles Lenox Remond became the first African American to speak before the Legislative Committee of the Massachusetts House of Representatives. This speech would influence the ending of segregation on Massachusetts railroads. Remond was also one of the operators of the Salem station on the Underground Railroad.[29]

Charlotte did very well in school. One of her poems was selected as the best from her class, to be recited at commencement. As her graduation day approached, friends and teachers encouraged her to take the entrance examination for the Salem Normal School, the recently opened teacher training college. No black student had attempted it yet. Charlotte took up the challenge.

On March 13, 1855, Charlotte Forten passed the entrance exam and became Salem Normal School's first African American student. Along

Surprising Salem

with studying, she joined the Salem Female Anti-Slavery Society. Again a successful student, she became Salem Normal School's first black graduate. She wrote in her diary that the day she received her diploma was "among the happiest in my life." From there, in an era when few schools in the country would hire a black teacher for white students, she secured a job with the Salem public school system and started earning $200 a year.

In 1862, her friend, poet John Greenleaf Whittier, told her how teachers were needed for the freed slaves on the Union-controlled island of St. Helena off the coast of South Carolina. Knowing the ex-slaves would need an education for a chance at a better life, twenty-five-year-old Charlotte volunteered and headed south. She taught 140 students in a single room, students who spoke Gullah and whose customs were alien to her as a northerner. She braved yellow fever, oppressive heat, impoverished living conditions and the ever-present danger of Confederate attack, knowing full well what would become of her if she ever fell into enemy hands. She did this until May 1864, when poor health forced her home. She would later return to teaching in South Carolina after the war at the Robert Gould Shaw[30] Memorial School in Charleston.

Charlotte deliberately chose this particular school. She had known Robert Gould Shaw. The young officer, the same age as herself, had been introduced to her while she was teaching on St. Helena. On their first meeting, Shaw described her as "quite pretty, remarkably well educated, and a very interesting woman." He wrote to his mother that Charlotte was "decidedly the belle here." Despite the house where the teachers stayed being five miles away, he seems to have ridden over to visit every chance he got.

Charlotte, on her part, wrote in her diary, "He seems to me in every way one of the most delightful persons I have ever met." He was gentle "and yet I never saw anyone more manly. To me he seems a perfectly lovable person."[31]

On another occasion, her diary details how he helped her onto her horse and, "after carefully arranging the folds of my riding skirt, said, so kindly, 'Goodbye. If I don't see you again down here I hope to see you at our house.'" She mused to herself that "the bravest are the tenderest" and hoped to see him many more times before they were back in Massachusetts.

She knew their affection was star-crossed, for Shaw was already married. She could not know he was about to be taken from her through more permanent means at a place called Fort Wagner. Having just endured a two-night march through poor conditions with insufficient rations to lead an infantry charge on a heavily fortified and armed installation that had

defeated similar tactics only a week ago did not dampen Shaw's spirits. But he did leave orders that if he were killed, one of his horses should be given to Charlotte.

Harriet Tubman, present at the time, described the attack on Fort Wagner so: "And then we saw the lightning, and that was the guns; and then we heard the thunder, and that was the big guns; and then we heard the rain falling, and that was the drops of blood falling; and when we came to get in the crops, it was dead men that we reaped."

Upon receiving news of the battle, Charlotte reacted as you might expect. "That our noble, beautiful young Colonel is killed, and the regiment cut to pieces! I cannot, cannot believe it…And oh, I still must hope that our colonel, *ours* especially he seems to me, is not killed." She left her teaching duties to go nurse his wounded men, repeatedly telling them that he was not dead, only captured by the enemy, and clearly hoping that if she said this often enough it would come true.

It didn't work. When confirmation finally came through that he was indeed dead,[32] she wrote of the massacre at Fort Wagner: "The beautiful head of the young hero was laid low in the dust. Never shall we forget the heartsickness with which we heard of his death—we who had seen him so lately in all the strength and glory of his manhood. We knew that he died gloriously, but still it seemed very hard."

When she was forty-one, Charlotte married Francis Grimké,[33] who had gone from being a slave to graduating from first Lincoln University and then the Princeton Theological Seminary and becoming a minister in Washington, D.C. Charlotte wrote and helped with her husband's ministry, and their home became a center for political activity. He helped start the National Association for the Advancement of Colored People. To fight for the rights of women as well, Charlotte became a founding member of the National Association of Colored Women in 1896.

Charlotte died in 1914. Preserved among her papers is an autographed picture of Shaw.

Salem's Chinese God

Frederick Townsend Ward was born in Salem on November 29, 1831. He grew up playing on Crowninshield Wharf, sailing in the bay and fighting alongside the "downtown" boys any time the "uptown" boys wanted a battle.

> *His appearance was striking. Of no more than medium stature and always slight, compact and wiry, he had the strength of an athlete, He was quick, nervous and animated in his movements, and his thick raven hair, hanging over his shoulders like an Indian's,—his broad forehead, which carried assurance of large intelligence,—his dark hazel eyes, surmounting a strong nose and firm-set mouth,—that heavy under-jaw without which force of will is rarely present,—all this bespoke…the robust vitality within. His eyes have been described as quick and restless, and as lighted up with fire by the intensity of his purpose. His complexion was sallow, bordering upon olive.*[34]

Desperate for adventure, he tried to volunteer for service in the Mexican War in 1847. His youth and his father put a stop to that. His father sent him to sea as second mate on a voyage to Hong Kong, but when Ward returned, he still wanted to be a soldier. So off he went to the American Literary, Scientific and Military Academy at Norwich, Vermont, now Norwich University.[35]

Lack of family finances cut his military education short, and he proceeded to traipse the world, beginning as first mate on a voyage to San Francisco and then off to places as geographically diverse as Shanghai and Nicaragua.

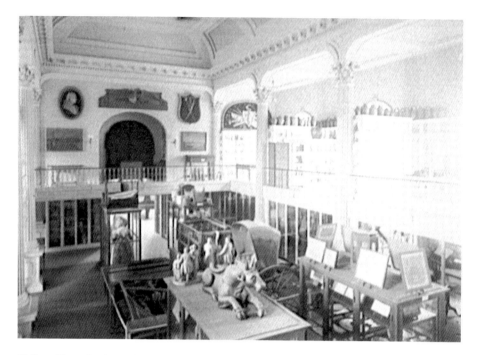

Gallery, Essex Institute, Salem. *Courtesy of Library of Congress, LC-D4-39485.*

Between 1852 and 1853, he became a soldier of fortune and joined William Walker's mercenary army. Perhaps Walker's ambition to create his own English-speaking, slaveholding empire in Central America didn't sit well with him, for Ward did not stay long. He left to travel overland through Mexico to California and then went back to the sea.

As an example of his character, there is this story of how he quelled a mutiny in the Bay of Bengal:

> *Captain Paul's ship was making for the Hugli River, on which the city of Calcutta lies, when a fierce squall came up. The crew was stunned by the suddenness of the storm and refused to go aloft to take in sail. The ship, with a full spread of canvas, was at the mercy of the storm.*
>
> *Captain Paul and the mates had exhausted the usual seamen's persuaders, belaying pins and the like. The crew had come to open mutiny. It was then that Ward, the first mate, showed the quality of desperate courage which was to distinguish him in the Taiping rebellion.*
>
> *He went to the powder locker, took a keg of powder, and knocked in its head. Running to the cook's galley he seized a burning brand of wood from*

the stove. With the keg of powder in one hand and a flaming brand in the other, he appeared among the crew and threatened to blow them and the ship to hell unless the mutineers went aloft.

One look at Ward was enough for the crew. They went aloft and the ship was saved.[36]

Early in 1860, Ward arrived in Shanghai. This was during the Taiping Rebellion. Always looking for action, he may originally have been thinking of joining the rebels, but he ended up fighting for the Imperial dynasty. His method of paid soldiering was unique. He proposed to the chairman of a committee of Chinese merchants that he would recapture the Shanghai district's capital from the rebels for a lump sum. "They must have been impressed with the coolness of the Yankee adventurer who offered to capture cities and deliver them at a stipulated price just as other foreigners might bargain for cargoes landed on the wharves of Shanghai. In this Ward was merely another of the good race of Salem merchants."[37]

His plan approved, Ward hired himself a force of men, both Chinese and Western, and in June 1860 attacked Sung Kiang, the capital. His first assault failed, but his second, with fewer than one hundred men, succeeded.

Then he began building the Chinese-European force that would become known as the Ever Victorious Army. The rebels called them "devil soldiers." His army earned these names in 1862 when Ward led them in victory after victory against rebel forces considerably larger than his.

Ward was given the title commander in chief. He married an aristocratic Chinese girl named Chang Mei. He used to joke, "The bullet is not made which will kill me."

Then, in September 1862, Ward's luck ran out. In leading the attack on the fortified town Cixi near Ningbo, he received a fatal wound. He nevertheless remained on the field until his troops were victorious.

Ward died September 22, 1862, at the age of thirty. After his death, Charles "Chinese" Gordon took command of the Ever Victorious Army. While Gordon is remembered[38] in the West, it was Ward who created, trained and organized this amazing force.

His friends remembered him fondly. Augustus Allen Hayes saw him just before he set out on his final campaign. "I looked up from my desk to see him standing beside me. I could not think of this smiling, amiable man as a great commander and future ruler. I only remembered that when I, a few months before, lay sick of that terrible Shanghai fever,

he had taken time from his cares and duties to come and sit by a young countryman's bedside."[39]

Neither did China forget Ward.

> The temple was dedicated on March 10, 1877 amid most impressive ceremonies. The procession moved off towards the tomb amid the banging of fire-crackers and bombs. There were sacrifices of goats, pigs, ducks, etc. then made, and at the end of the dedication there were more fireworks and gongs. Inside the temple is a shrine upon which burnt-offerings are laid in February of every New Year to the Manes of General Ward, and to which official prayers are offered every month in the year by officials of the Chinese Government.
>
> The inscription at the entrance of the shrine reads, "A wonderful hero from beyond the seas, the fame of whose deserving loyalty reaches round the world, has sprinkled China with his azure blood."[40]

According to Mary Caroline Crawford, "The mausoleum soon became a shrine invested with miraculous power, and a number of years after his death General Ward was solemnly declared to be a joss or god. The manuscript of the imperial edict to this effect is now preserved in the Essex Institute."

His shrine is gone now. His bones are lost. Ward has a cenotaph in Salem, but your average visitor is not going to find him when faced with Harmony Grove Cemetery's rolling seventy-five acres. For all that, fate works in mysterious ways…

Kitty-corner from where Frederick Townsend Ward was born is a Veterans of Foreign Wars post. I think he would have liked that.

Entertaining Salem

Mike Martin was an Irish highwayman who went by the name Captain Lightfoot. Just like the highwayman one imagines when reading Alfred Noyes's poem, Martin had a pair of fine pistols and a splendid horse.[11] When Ireland grew too hot for him, he sailed for the New World and landed at Salem June 17, 1819. For a while, he worked for Elias Hasket Derby as a farm laborer. He wrote in his autobiography:

> I remained with Mr. Derby about fourteen months—during which time, I labored harder than I ever did before in my life. I believe Mr. D. was generally satisfied with me; but I would sometimes get drunk, and neglect my work.
>
> Whenever I received any money, I would go to Salem, and have a great blow out, and then would be very inattentive and quarrelsome.
>
> After having given me many warnings, Mr. D. was compelled to dismiss me. During my stay there, I was treated with much kindness and attention by Mr. Derby and his family; and might have remained there, honestly and quietly, if it had not been for my disposition to intemperance and riot. I never stole any thing while I was there, nor wronged Mr. Derby of a sixpence.
>
> After leaving Mr. Derby's, I roved about in dissipation and idleness, for some weeks, when I found that it was necessary to attempt some means to get a decent living. I might then have taken to my old trade of robbery; but I had made up my mind to be as honest as I could. I engaged myself to a brewer in Salem, and worked tolerably well for a few weeks—having no

other vices to reproach myself with, during this time, than intemperance and gambling.

Martin then went into the brewery business on his own but, faced with many bad debts, had to admit failure in May 1821. He left Salem and once again turned highwayman. However, even when he was on the run, Salem was still the place he turned to for entertainment. "We agreed to meet in Salem, and have a good blow out—We spent the day and night, drinking and carousing—all at my expense."

Martin's luck did not last. After a series of audacious robberies, he was finally caught and tried. He received the death penalty. "He stood unmoved, and when the sentence was pronounced, with the most perfect nonchalance, took up his hat, saying, 'Well, that is the worst you can do for me.'"

After helping them fix the noose about his neck, Martin was hanged outside the Middlesex County jail in Cambridge, December 20, 1821. He was twenty-six years old. Tall, handsome, with a fair complexion and blue eyes, Alice Morse Earle wrote that he "really was a very satisfactory outlaw" and, "It must have been a pleasure to meet him." He never stole from ladies, after all.

But what would make a hunted outlaw continue to come to Salem for his entertainment? As it turns out, Salem was an exceptionally entertaining place.

Places of Entertainment

Hamilton Hall is today one of the finest examples of a Federal-era public building and a testament to the skill of Salem-born architect and woodcarver Samuel McIntire. It was built at a cost of $22,000 in 1805. Four mirrors were imported from Russia to grace the fireplaces on the eastern and western portions of the ballroom on the second floor. The floor itself was built as a "spring floor" and "is extremely pleasant for dancing."

Off the ballroom was the Lafayette Room, named for the Revolutionary War hero who visited Salem twice, the second time attending a party in his honor at Hamilton Hall. Supper was served on the third floor under an arched ceiling. Food for this repast was prepared on the first (ground) floor. One of the ovens in the kitchen was a Rumford roaster. Count Rumford, the inventor of said roaster and also inventor of the Rumford fireplace, familiar to readers of Jane Austen, was a Massachusetts boy named Benjamin Thompson who lived for a while in Salem.

Entertaining Salem

Hamilton Hall. Site of "genteel parties" with a dancing hall, supper hall, ladies' drawing room and its own Salem Quadrille Band. *Courtesy of Library of Congress, HABS MASS,5-SAL,37-1.*

Hamilton Hall was named in honor of Alexander Hamilton, who was a guest of Benjamin Pickman in Salem when it opened for its first assembly "the Thursday after Christmas in 1805." "Everything was order and decorum, from the managers down to the waiting-maids. The numbers were called at half past six; supper at ten; music dismissed at twelve."

Another description of a Hamilton Hall assembly is as follows:

> *The assembly opened with two contra dances partners for which were drawn; this added much to the excitement of the evening for the guests never knew who might be their partners, listening to the calling in order to take their places on the opposite sides of the room. The style of dancing was far different from that of today. It was to jump high, cross the feet and avoid sliding; waltzes had not come into style but the Virginia Reels and Polkas were in vogue. The musicians were stationed in the balcony that was built in the center over the entrance door.*[12]

Assembly House. Another place to party. Traveling waxwork shows could also be seen here. *Courtesy of Library of Congress, LC-D4-39468.*

Hamilton Hall was not the first of its kind in Salem, of course. Previously, there had been the Assembly House on Federal Street, built in 1782. It possessed a ballroom on its first (ground) floor that could accommodate over two hundred people. Not only dances but musical concerts, theatrical productions and traveling shows, such as waxwork collections, could be experienced here as well. Both the Marquis de Lafayette and President George Washington were fêted in this Assembly House. However, in the mid-1790s, Judge Samuel Putnam purchased the Assembly House and hired Samuel McIntire to redesign it as a home for himself and his family.

For entertainment outside, in 1858 came the thirty-five-acre Salem Willows Park, named for its white willow trees. In 1866, a flying horse carousel was added. Bavarian woodcarver Joseph Brown created the horses,

and such works of art were they that, even after decades of children riding them, Macy's department store in New York City purchased all the horses for its 1945 Christmas window displays.

In the 1880s, more amusements were added, such as the Willows Pavilion, which had a roller-skating rink and live orchestra on the ground floor and a huge restaurant on the second. A camera obscura in the pavilion's tower projected scenes from the neighboring cities of Beverly and Marblehead.

The Willows Park Theatre held open-air concerts. There were harbor cruises and a water chute ride. Shooting ranges, bowling alleys, bathhouses and roller coasters all followed, along with a casino, a dance hall and more eateries than you could ever hope to experience.

In 1906, Everett Hobbs and William Eaton offered ice cream cones to the curious public, possibly the first ice cream cones ever served. E.W. Hobbs ice cream is still to be found at the Willows, along with its original 1897 saltwater taffy and popcorn.

Entertaining Music

Salem liked brass bands, and one of the most famous American bandleaders was once a resident of Salem. Patrick S. Gilmore came to Salem May 1, 1855. He was the first to separate the brass band from military affiliations. He "proved that the band could succeed as an independent ensemble in the public arena."

Gilmore took over the Salem Brass Band in 1855. Under his direction, the Salem Brass Band won a national reputation. It was invited to play at President James Buchanan's inauguration day parade in 1857.

Gilmore resigned from the Salem Brass Band in 1858 to form his own, Gilmore's Band. You probably think you don't know Patrick S. Gilmore. You do. He wrote "When Johnny Comes Marching Home Again" in 1863 under the pseudonym Louis Lambert, and he introduced it to the public when it was played by Gilmore's Band.

Salem slipped into a bit of musical Gold Rush history as well. This song was sung on the ship *Eliza*, which sailed from Salem in December 1848 as part of the California Gold Rush. The tune is "Oh! Susanna":

> *I came from Salem City*
> *With my wash bowl on my knee,*
> *I'm going to California*

"When Johnny Comes Marching Home." *Historic American Sheet Music, A-5654, Duke University Rare Book, Manuscript, and Special Collections Library.*

*The gold dust for to see.
It seemed all night, the day I left,
The weather it was dry,
The sun so hot I froze to death,
Oh! brothers, don't you cry.*

*Chorus:
Oh! California,
That's the land for me,
I'm going to Sacramento
With my wash bowl on my knee.*

It became a popular song on board many vessels sailing from Salem, even those not destined for California.

Entertaining Animals

In 1798, Salem had the pleasure of viewing a "Sapient Dog" that could "light lamps, spell, read print or writing, tell the time of day, or day of the month. He could distinguish colors, was a good arithmetician, could discharge a loaded cannon, tell a hidden card in a pack, and jump through a hoop, all for twenty-five cents."[43]

About the same time, Mr. Pinchbeck exhibited in Salem a "Pig of Knowledge."

> *The Pig of Knowledge reads print or writing, spells, tells the time of day, both the hours and minutes, by any person's watch in the company, the date of the year, the day of the month, distinguishes colors, how many persons there are present, ladies or gentlemen, and to the astonishment of every spectator, will answer any question in the four first rules of Arithmetic. To conclude, any Lady or Gentleman may draw a card from a pack, and keep it concealed, and the Pig without hesitation will discover the card when drawn.*[44]

Apparently, Britain had no corresponding pig and found the American Pig of Knowledge's intelligence threatening. *Porcupine's Works: Containing Various Writings and Selections Exhibiting a Faithful Picture of the United States of America*, published in London, went to the trouble of producing an entire poem on how the Lion (symbol of Britain) was better than the Pig of Knowledge:

> *Tell us no more of your learned little pig,*
> *In size a mere runt, though in science very big.*
> *Tell us no more of your little pig of knowledge,*
> *Who can cipher and spell like a sophomore at college.*
> *Can the grunting little thing, which you set so very high on,*
> *Be compared to our beast, the Great And Mighty Lion?*

The argument for superiority seems to rest entirely on the assumption that the Lion could beat up the Pig—forgetting that a crafty Pig would probably never get that near a Lion.[45]

Another animal that graced Salem streets was the United States' first elephant, brought to America by the *America*, a Salem ship, under Jacob Crowninshield, a Salem captain. Captain Jacob Crowninshield, who would

later be appointed secretary of the navy, purchased this elephant in India for $450. His brother Ben thought he was crazy and did not support his plan. Jacob wrote to his brothers John and George Jr.: "I suppose you will laugh at this scheme, but I do not mind that, will turn elephant driver. We have plenty of water at the Cape and St. Helena. This was my plan. Ben did not come into it, so if it succeeds, I ought to have the whole credit and honor too; of course you know it will be a great thing to carry the first elephant to America."

Being a good Salem merchant, he hoped to make a profit in selling the elephant, thinking her price might go as high as $5,000.

We don't have details of the voyage, but Nathaniel Hawthorne's father kept the log of the *America*, and his writing grows huge when he records, "ELEPHANT ON BOARD." She must have been a source of wonder to her fellow sailors. And they must have kept her well, for when the *America* arrived at New York in April 1796, a Mr. Owen immediately offered to buy the elephant for $10,000. Just to give you an idea of how much this was, Jacob and Ben Crowninshield had bought the ship *America* itself from Elias Hasket Derby for $9,000.

The elephant traveled up and down the eastern seaboard for years, going south for the winters. When she arrived in Salem, a broadside dated August 29, 1797, titled "THE ELEPHANT" announced her. Admission was twenty-five cents, and that was obviously acceptable to Salem's citizens, as Dr. Bentley wrote, "The crowd of spectators forbade me any but a general and superficial view of him." He described her as six feet, four inches tall, her skin black and shiny, and she was independent despite the wishes of her trainer.

> *Of large Volume, his skin black as tho' lately oiled. A short hair was on every part but not sufficient for a covering. His tail hung one third of his height, but without any lone hair at the end of it…Bread and Hay were given him and he took bread out of the pockets of the spectators. He also drank porter and drew the cork, conveying the liquor from his trunk into his throat. His Tusks were just to be seen beyond the flesh and it was said had been broken. We say his because this is the common language. It is a female, and teats appeared just behind the fore legs.*

Over the years, more elephants were brought to America, and there is some debate as to what happened to this particular elephant, which is

Entertaining Salem

Monument to Old Bet at the Elephant Hotel. *Courtesy of Library of Congress, HABS,NY,60-SOM,1-3.*

surprising since one might expect the public to keep track of the first. Some records say she was acquired by Hackaliah Bailey around 1805 and named Old Bet. Since this is the Bailey of future Barnum and Bailey Circus fame, it would have been appropriate for him to purchase America's *first* elephant, as opposed to just any elephant.

When she died, Bailey erected a monument to Old Bet on the green in front of his Elephant Hotel at Somers, New York, about fifteen miles east of Peekskill. This would make Old Bet not only the first elephant to arrive in America but also the only elephant to have been given such a memorial. It still stands today.

Living in Salem meant you could see many exotic animals, including Arabian horses. These horses were rare in America.[46]

> *In the spring of 1844, Colonel Leavitt gave an interesting private horse show at the Essex House stable,[47] one that we all attended. The reason for holding it was the arrival on the bark* Eliza *of a pair of Arabian stallions that had been presented to him by the Sultan of Muscat through his old friend, Palmer Waters, who was Consul there. They were picked out as the finest specimens of the famous stock and were tended by Arab grooms wearing turbans, long robes, sandals and full native rig showing bare legs and speaking no word of English. It was necessary for the grooms to come over with the horses, for the animals understood commands only in Arabic and recognized, therefore, only the control of the groom. It was one of the most interesting sights I have ever seen, and the concourse from Chestnut Street that went to see them enjoyed the exhibition exceedingly.*[48]

Probably the most unconventional animal to be seen from Salem is the New England sea serpent. First sighted in 1638, the sea serpent was "coiled up on a rock at Cape Ann" (up the coast from Salem). The English colonists would have shot at it, but the Indians with them warned "that if he were not killed outright, they would be all in danger of their lives."

After that, the New England sea serpent was sighted off and on for years, not without some disbelief on the part of those who had not witnessed it, until 1817, when so many people saw it that its reality almost stopped being questioned. This was the year it was seen from Salem.

Salem's Reverend Dr. Bentley, well educated and not inclined to fancies nor hallucinations, would seem a most reliable witness. He wrote in his diary on September 30, 1817: "We saw the Serpent. It would not have been

suspected to have had a sea origin had it not been for the protuberances by which it is distinguished and for the agreement they have with the representation of the Sea Serpent."

The serpent visited again the following year. On August 7, 1818: "Our friends, 18 from this town, are out in two Vessels, one a Schooner, after the sea serpent. The conditions are day wages, if they do not take him, and a share in the fish if they take him. Companies are said to be out in the bay from different towns, but we hear of no success."

Next summer the serpent was back:

> *June 8, 1819—The Sea serpent so much laughed at has appeared again… We hope that Gloucester will have an opportunity to turn the laugh upon unbelievers.*
>
> *August 17, 1819—The sea serpent puzzles us. We shall be laughed at till we take him. He was seen last Saturday by several hundred persons near Nahant. They differ nothing in their description of it. This is the fourth time he has been seen in the bay lately. But we do not take him.*

And they never would. The New England sea serpent avoided everyone who tried to catch him. He was seen again in 1826 by passengers on the ship *Silas Richards*. One of these witnesses was a member of Barclay Brothers & Co. of London who described the Serpent as "about 60 feet long, with humps upon his back like those of a dromedary."

In 1830, the serpent approached a fishing boat off the New England coast, "came within six feet of the vessel, raised his head, and looked over the deck. The party on board fled to the cabin and when they emerged again the Serpent had disappeared."

Boston saw him in 1833, but he once again slipped away from his pursuers. Then on August 6, 1848, a serpent matching his description was seen by the *Daedalus*, a British frigate. Although this was far from the Massachusetts coast, it gave believers in the New England sea serpent a boost because of the respectability of the witnesses and the fact that these military men stood by their description of what they saw despite ridicule from some scientists.

The officers and crew described the animal they witnessed as "an enormous serpent, with head and shoulders kept about four feet above the surface, nearly sixty feet in length, dark brown, and yellowish white about the throat." He came very near the frigate and stayed twenty minutes.

The captain of the *Daedalus* told Admiral Sir W.H. Gage:

> *It passed rapidly, but so close under our lee quarter, that had it been a man of my acquaintance, I should easily have recognized his features with the naked eye; and it did not, either in approaching the ship or after it had passed our wake, deviate in the slightest degree from its course to the S.W., which it held on at the pace of from twelve to fifteen miles per hour, apparently on some determined purpose.*

At this point even the Royal Society of Edinburgh discussed what the men of the *Daedalus* could have seen. It continued to be a topic of interest in Britain, and as late as 1901, London's *Pall Mall Magazine* ran an article on the sea serpent.

Sightings along the Massachusetts coast waned in the twentieth century. He was last seen off Massachusetts in 1962. Then, in 1997, a serpent matching his description was seen off Fortune Bay, Newfoundland. Is the New England sea serpent still around?

Regardless of where he is currently, there certainly was something swimming in Salem's waters between 1817 and 1819. So many different people saw the same thing so many different times that even Richard Ellis, marine painter and authority on ocean life, writes that the New England sea serpent is "one of the great unsolved mysteries of sea serpent lore." While cryptozoologists can explain the sightings of many other water monsters, the New England sea serpent "simply cannot be encompassed by any rational explanation."

Entertaining People

You could also see entertaining people in Salem. Native to Salem was Charles H. Foster, the Salem Seer, "undoubtedly the most gifted and remarkable Spiritual Medium since Emanuel Swedenborg," according to one of his fans. He traveled widely in America, Australia and Great Britain. Foster met Edward Bulwer-Lytton, and the character of Margrave in Bulwer-Lytton's *A Strange Story* (1862) is said to be based on him.

One of Foster's "peculiar gifts" was to be "able to bring out the name or initials of the spirit which he described upon his own skin, usually upon his forearm." An account of a séance with Foster was written up in the *Alta Californian*:

Entertaining Salem

A Salem game. Win electoral votes away from other players! *Courtesy of Library of Congress, rbpe 05802800.*

Four journalists spent an hour yesterday afternoon with Charles H. Foster, the spiritual medium. They were skeptical and suspicious. Before going into the room they had each written six or eight names of deceased friends on pieces of paper four inches long and one inch wide, which were then folded

over five or six times longitudinally, with the name inside and no mark on the outside to distinguish them. They were all thrown into a hat, and none of the party could, by looking at the outside of any paper, know that he had written on it, much less tell the name in it…

Mr. Foster, without opening the folded papers, told the names in them correctly, and in every case mentioned some remarkable fact connected with the deceased person. One was drowned at sea, another shot in battle, another committed suicide, a fourth had died under very painful circumstances, and so on…

After showing his bare arm with no mark on it, the letters "A.L.," the initials of the name of one of the "spirits," came out in red color on the arm before the eyes of the whole party. Every question asked was answered.

Sometimes his performances involved "possession." During a séance in 1874, "He told me he saw the spirit of an old woman close to me, describing most perfectly my grandmother, and repeating: 'Resodeda, Resodeda is here; she kisses her grandson.' Arising from his chair, Foster embraced and kissed me in the same peculiar way as my grandmother did when alive."

The Salem Seer was invited to the White House by Mrs. Lincoln in the winter of 1864–65. He also appeared before Napoleon III in Paris. Belgium's King Leopold sent him a diamond ring. He gave séances for the Duke of Wellington, Lord Palmerston, Tennyson and Edmund Yates. While he lived, his séances were considered extremely popular and fashionable.

Foster died in 1888 and ever since has been regarded as having "a chequered career." In 1920, Hereward Carrington wrote, "That Foster was an impostor there can be no doubt." He goes on to show how trickery could produce the same effects as Foster's séances.

On the other hand, Harry Houdini's legend has done nothing if not grow since his death in 1926. Houdini not only performed magic, but he also performed impossible escapes. He traveled across America and through Great Britain, Europe and Russia. In each city, he challenged the local police to handcuff and shackle him and secure him in their jail. He issued this same challenge to the Salem police when he came to Salem.

At this time, the Salem Police Station was on Front Street. The *Salem Evening News* of April 17, 1906, ran the story of "Mr. Houdini's feat at the Salem police station yesterday morning": "Houdini released himself from three pairs of police hand cuffs and two pairs of leg irons, got out of one cell and into another, where every stitch of his clothing had been locked, opened

Entertaining Salem

Portrait of Harry Houdini in chains. *Courtesy of Library of Congress, LC-USZ62-112419.*

a third cell and shackled himself to a prisoner, unlocked the outside door and walked around to the city marshal's office all in 13 minutes by the watch."

Houdini had a three-day engagement at the Salem Theatre, during which he not only escaped from all sorts of manacles but also defeated a straitjacket, according to the article.

> *A challenge had been handed up…asking if Houdini would consent to free himself from a straight jacket such as is used to control insane persons, and do it in the view of the audience. Houdini allowed that he would, and the canvas straight jacket was laced upon him. His arms, both hands being covered with the long closed sleeves, were lashed tightly around him and the ropes tied with a dozen or more hard knots behind his back and a stout leather strap buckled about his neck.*
>
> *Everybody being ready, Houdini threw himself upon the floor, squirmed and struggled, dislocated his shoulders so that his hands were above his head, fussed with the strap a moment, and wriggled down out of the*

Salem Theatre lobby display from April 18, 1906. *Courtesy of Library of Congress, LC-USZ62-112382.*

Entertaining Salem

jacket—in exactly one minute and 29 seconds, or about one-third the time it took the policemen to lash him into it. Dusty, disheveled and perspiring, Houdini bowed in acknowledgment of the storm of applause.

Houdini played to full houses in Salem, as one might expect. In 1990, a Halloween séance was held in the ballroom of Salem's Hawthorne Hotel to see if Houdini would come back. He didn't.

ENTERTAINING MUSEUM

The East India Marine Society was founded in 1799. Only masters or supercargoes of Salem ships that had voyaged around the Cape of Good Hope or Cape Horn could join. Part of one's duties as a member was to bring back items from all corners of the world. And bring them back, they did. In 1824, needing more room for its wide array of curiosities, the society built the massive, granite East India Marine Hall.

East India Marine Hall. Rent it for your wedding! It's featured in *Bride Wars*. *Courtesy of Library of Congress, HABS MASS,5-SAL,49-6.*

Nathaniel Hawthorne's *A Virtuoso's Collection* may have been a loving satire on the eclectic collection housed in the East India Marine Hall. In his *Collection* are such prizes as the wolf that ate Little Red Riding Hood, Pandora's Box, Dr. Johnson's cat Hodge, Nero's fiddle and a bowl "which a sculptor modeled from the curve of [Helen of Troy's] perfect breast." The hall's collection was not quite that fanciful, but it did have a wild assortment of natural and man-made souvenirs.

> *It is especially rich in South Sea Island implements, cloths, models, idols, domestic utensils, etc., and Chinese, Japanese, and East Indian life-size models of native characters, besides the boats, clothing, utensils, implements of war and of domestic use from these countries, and from Africa, Arabia, and North and South America. The collection from Japan is very fine...A collection from Korea and another illustrating the Indian Tribes of North America, have just been added to the museum. (1887)*[19]

One could also find the "Natural History and Archaeology of Essex County."

> *Nearly all of the species of the flora and fauna are represented by preserved specimens; the collection of birds and that of native woods being especially fine. The academy has, also, the best local collection of prehistoric implements and utensils of stone, bone and clay to be found in Essex County. An educational collection of minerals has recently been arranged in the central gallery case.*[50]

Mormon leaders Joseph Smith, Sidney Rigdon and Oliver Cowdery all visited the East India Marine Hall museum when they were in Salem in 1836. Because she was told it had to be seen, English singer and actress Emily Soldene made a "pilgrimage" to it in 1889.[51] You can visit it, too, as the hall is now part of the Peabody Essex Museum.

Entertaining Lectures

Even before the Salem Lyceum was incorporated March 4, 1830, Salem had a reputation for great lecture series. Ralph Waldo Emerson lectured lyceum audiences more than forty times. Salem never tired of him. Not only did he

lecture "very beautifully," according to the *Salem Gazette*, but "the ladies run after him a great deal."

Women couldn't buy tickets on their own; they had to be "introduced by a gentlemen" in order to qualify for a ticket. However, by 1832 there were 1,200 gentlemen members of the lyceum, so Emerson easily could have been in danger of being mobbed by ladies.

Charles W. Upham lectured on Salem witchcraft. Henry Ward Beecher lectured on patriotism. From the Roman Empire to phrenology, a wide range of topics was expounded upon by acknowledged experts in their fields. When Nathaniel Hawthorne was the lyceum's secretary, he invited Daniel Webster, Charles Sumner and Henry David Thoreau to speak. He wouldn't lecture himself, though.

One of Salem's most groundbreaking lectures would be given by two Salem residents while one of them was actually in Boston. Thomas Augustus Watson was born in Salem January 18, 1854. He was educated in Salem public schools. In the autumn of 1874, a man came into the Boston machinist shop where he was employed needing some work done. The job was assigned to him. The man's name was Bell. He was only seven years older than Watson and was also commuting from Salem by train.

Alexander Graham Bell moved to Salem on October 1, 1873, receiving free room and board in exchange for teaching his landlady's deaf grandson. He commuted by train to his job at Boston University.

Together, Bell and Watson struggled to build a speaking telegraph until, in 1876, America's centennial, Bell told Watson he was wanted and Watson rushed down the hall to tell him he'd heard the message, and the telephone[52] was born.

On February 12, 1877, at Lyceum Hall in Salem, Bell gave a free telephone demonstration as part of the lecture series. He played "Auld Lang Syne" and "Yankee Doodle" on the "telephonic organ" and then "paid a graceful tribute to Mr. Watson, a Salem man." At which point Watson called him from Boston.

The telephone box Bell used was like a speakerphone, so the audience heard Watson's "Hoy"[53] and "it seemed as if an electric thrill went through the audience, and that they recognized for the first time what was meant by the telephone." When Bell spoke across the wire to a *Boston Globe* reporter, this became the first newspaper report ever transmitted by telephone.

The Salem lecture made both national and international news. An illustrated report was carried by both the *New York Daily Graphic* and *Scientific American*. The London *Athenaeum* ran the story, as did the Paris *La Nature*.

Bell writing his father of his success at Salem. *Courtesy of Library of Congress, Manuscript Division.*

So popular was it that Bell gave his presentation again on February 23. The *Providence Star* titled its article on this demonstration "Salem Witchcraft." The magic of Salem would again be brought up when the first transcontinental telephone call was made.

> Professor Bell says that he thought out the telephone in Salem. A fitting place for its conception—there is witchcraft in it, and the most blasé of businessmen in the offices of the American Telephone & Telegraph Company on Monday [January 25, 1915] felt something akin to uncanniness at the thought that his voice had gone across thirteen States, shot over prairies and through forests, hurtled through cities, climbed the Rockies, skimmed across

the desert and reached the Pacific coast, and the answer had come back to him in an eye-wink.[54]

Bell and Watson were both on hand for the opening of this line, Bell in New York and Watson in San Francisco. Bell repeated his famous first telephonically sent words: "Mr. Watson, come here, I want you." Watson joked, "It would take me a week to get there now."

Literary Salem

I had a wonderful day at Salem. A soft sea-mist hung over the town as I wandered about it. I was deeply impressed with the strange sentiment of the place, and walked about the streets until I was thoroughly soaked with the old Puritan spirit.
—*Edmund Gosse, English poet*

When Sir James Barrie was in Salem, it devolved upon me to show him about. He was wholly unprepared to find that there was such a piece of legislation on the statute books as the "Scarlet Letter" law. I showed him the Colonial statute in the original type. He had thought of it, up to that time, only as a creation of Hawthorne's fancy.
—*Robert Rantoul*

The "Scarlet Letter" law, which continued in force until February 17, 1785: Both man and woman to be set on the gallows an hour with a rope about their neck and the other end cast over the gallows. And in the way from thence to the common jail, to be scourged, not exceeding forty stripes. And forever after to wear a capital A of two inches long of a contrary color to their clothes sewed on their upper garments on the back or arm in open view. And as often as they appear without it, openly to be scourged, not exceeding fifteen stripes.

Nathaniel Hawthorne is probably the first author who comes to mind when one thinks of literature and Salem. Not only was he born here, but his classic works *The Scarlet Letter* (1850) and *The House of the Seven Gables* (1851) both involve Salem. Hawthorne himself had a sort of love-hate relationship with the city.

Literary Salem

Nathaniel Hawthorne's birthplace. *Courtesy of Library of Congress, LC-D4-11985.*

> *This old town of Salem—my native place, though I have dwelt much away from it, both in boyhood and maturer years—possesses, or did possess, a hold on my affections, the force of which I have never realized during my seasons of actual residence here…And yet, though invariably happiest elsewhere, there is within me a feeling for old Salem, which, in lack of better phrase, I must be content to call affection.*

But Hawthorne is hardly a hidden part of Salem, so let's look for other appearances of Salem in the field of literature.

JONES VERY

Nathaniel Hawthorne was not the only writer to be born in Salem, of course. Also born in Salem was poet Jones Very (1813–1880). Hawthorne mentions Very in *A Virtuoso's Collection*: "From Jones Very, a poet whose voice

is scarce heard among us by reason of its depth, there was a Wind Flower, and a Columbine."

Very was considered an "inspired recluse poet and mystic" by his friends and somewhat insane by the people he annoyed with his advice "speaking as the messenger of God."

"The Barberry-Bush"
The bush that has most briars and bitter fruit,—
Wait till the frost has turned its green leaves red,
Its sweetened berries will thy palate suit,
And thou may'st find e'en there a homely bread.
Upon the hills of Salem, scattered wide,
Their yellow blossoms gain the eye in Spring;
And straggling e'en upon the turnpike's side,
Their ripened branches to your hand they bring.
I've plucked them oft in boyhood's early hour,
That then I gave such name and thought it true;
But now I know that other fruit as sour
Grows on what now thou callest Me *and* You;
Yet, wilt thou wait the Autumn that I see,
Will sweeter taste than these red berries be.

Henry Wadsworth Longfellow

"Salem Witchcraft"
Delusions of the days that once have been,
Witchcraft and wonders of the world unseen,
Phantoms of air, and necromantic arts
That crushed the weak and awed the stoutest hearts,—
These are our theme tonight; and vaguely here,
Through the dim mists that crowd the atmosphere,
We draw the outlines of weird figures cast
In shadow on the background of the Past.
Who would believe that in the quiet town
Of Salem, and amid the woods that crown
The neighboring hillsides, and the sunny farms

Literary Salem

That fold it safe in their paternal arms,—
Who would believe that in those peaceful streets,
Where the great elms shut out the summer heats,
Where quiet reigns, and breathes through brain and breast
The benediction of unbroken rest,—
Who would believe such deeds could find a place
As these whose tragic history we retrace?
'Twas but a village then: the goodman ploughed
His ample acres under sun or cloud;
The goodwife at her doorstep sat and spun,
And gossiped with her neighbors in the sun;
The only men of dignity and state
Were then the Minister and the Magistrate,
Who ruled their little realm with iron rod,
Less in the love than in the fear of God;
And who believed devoutly in the Powers
Of Darkness, working in this world of ours,
In spells of Witchcraft, incantations dread,
And shrouded apparitions of the dead.
Upon this simple folk "with fire and flame,"
Saith the old Chronicle, "the Devil came;
Scattering his firebrands and his poisonous darts,
To set on fire of Hell all tongues and hearts!
And 'tis no wonder; for, with all his host,
There most he rages where he hateth most,
And is most hated; so on us he brings
All these stupendous and portentous things!"
Something of this our scene tonight will show;
And ye who listen to the Tale of Woe,
Be not too swift in casting the first stone,
Nor think New England bears the guilt alone.
This sudden burst of wickedness and crime
Was but the common madness of the time,
When in all lands, that lie within the sound
Of Sabbath bells, a Witch was burned or drowned.

William Wetmore Story

"Salem"
Swift fly the years. Too swift, alas!
A full half-century has flown,
Since, through these gardens fair and pastures lone
And down the busy street,
Or 'neath the elms whose shadows soft are thrown
Upon the common's trampled grass,
Pattered my childish feet.
Gone are the happy games we played as boys!
Gone the glad shouts, the free and careless joys,
The fights, the feuds, the friendships that we had,
And all the trivial things that had the power,
When Youth was in its early flower,
To make us sad or glad!
Gone the familiar faces that we knew,
Silent the voices that once thrilled us through,
And ghosts are everywhere!
They peer from every window-pane,
From every alley, street, and lane
They whisper on the air.
They haunt the meadows green and wide,
The garden-walk, the river-side,
The beating mill adust with meal,
The rope-walk with its whirring wheel,
The elm grove on the sunny ridge,
The rattling draw, the echoing bridge;
The lake on which we used to float
What time the blue jay screamed his note,
The voiceful pines that ceaselessly
Breathed back their answer to the sea,
The school-house, where we learned to spell,
The church, the solemn-sounding bell,—
All, all, are full of them.
Where'er we turn, howe'er we go,
Ever we hear their voices dim

Literary Salem

That sing to us as in a dream
The song of "Long ago."

Ah me, how many an autumn day
We watched with palpitating breast
Some stately ship, from India or Cathay,
Laden with spicy odors from the East,
Come sailing up the bay!
Unto our youthful hearts elate
What wealth beside their real freight
Of rich material things they bore!
Ours were Arabian cargoes, fair,
Mysterious, exquisite, and rare;
From far romantic lands built out of air
On an ideal shore
Sent by Aladdin, Camaralzaman,
Morgiana, or Badoura, or the Khan.
Treasures of Sinbad, vague and wondrous things
Beyond the reach of aught but Youth's imaginings.

How oft half-fearfully we prowled
Around those gabled houses, quaint and old,
Whose legends, grim and terrible,
Of witch and ghost that used in them to dwell,
Around the twilight fire were told;
While huddled close with anxious ear
We heard them, quivering with fear,
And, if the daylight half o'ercame the spell,
'Twas with a lingering dread
We oped the door and touched the stinging bell
In the dark shop that led,
For some had fallen under time's disgrace,
To meaner uses and a lower place.
But as we heard it ring, our hearts' quick pants
Almost were audible;
For with its sound it seemed to rouse the dead,
And wake some ghost from out the dusky haunts
Where faint the daylight fell.

Upon the sunny wharves how oft
Within some dim secluded loft
We played, and dreamed the livelong day,
And all the world was ours in play;
We cared not, let it slip away,
And let the sandy hour-glass run,
Time is so long, and life so long
When it has just begun.

H.C. Gauss

"Salem, Condita 1626"
So you visited Salem?
And you saw the Witch House
And Gallows Hill?
And the House of Seven Gables,
And Hawthorne's birthplace?
But you did not see Salem.
How could you?
It has been shut up in my heart for forty years.
I think I was the last who saw it.

How could you see Salem?
You never lived with maiden aunts
Who remembered better days
And nothing else.
You never went to school
Next a graveyard
To a grim old dame who
Denounced youth and pleasure
With savage Scripture readings.

You never peeped, with splendid awe,
Beneath closed blinds
To see wraiths of women
Nursing life-long grudges or heart pangs
Shut in from the light of day.

Literary Salem

You never ran away
To sit for hours with gray men
Who talked of Hong-Kong and Sumatra
Of Singapore and Java
As one talks of the corner grocery
Or the cobbler next street.

You never had idle ships and wharves
And empty granite warehouses
For playgrounds
Nor roamed through great
Three-story houses with infinite rooms,
All full of dust of the departed
Where even the mice were venerable.

All this I did, and
I can see Salem.
I would like to show it to you,
But if I touch it,
It crumbles.

John Greenleaf Whittier

Long they sat and talked together,—talked of wizards Satan-sold;
Of all ghostly sights and noises,—signs and wonders manifold;
Of the spectre-ship of Salem, with the dead men in her shrouds,
Sailing sheer above the water, in the loom of morning clouds;
—from "The Garrison of Cape Ann"

The Reverend Cotton Mather relates in his *Magnalia Christi Americana* the tale of Salem's ghost ship. The reverend referred to in Whittier's poem "The Spectre Ship of Salem" is Zebedee Stebbin, and the name of the ship itself was *Noah's Dove*.

"The Spectre Ship of Salem"
The morning light is breaking forth
All over the dark blue sea—

Not a ghost ship. The *Friendship* of Salem at Derby Wharf. *Patrick Stanbro, www.patrickstanbro.com.*

And the waves are changed—they are rich with gold
As the morning waves should be;
And the rising winds are wandering out,
On their seaward pinions free.

The bark is ready—the sails are set,
And the boat rocks on the shore—
Say why do the passengers linger yet?—
Is not the farewell o'er?
Do those who enter that gallant ship
Go forth, to return no more?

A wailing rose by the water-side,
A young, fair girl was there—
With a face as pale as the face of death
When its coffin-lid is bare;—
And an eye as strangely beautiful
As a star in the upper air.

Literary Salem

She leaned on a youthful stranger's arm,
A tall and silent one—
Who stood in the very midst of the crowd,
Yet uttered a word to none:
He gazed on the sea and waiting ship—
But he gazed on them alone!

The fair girl leaned on the stranger's arm,
And she wept as one in fear;
But he heeded not the plaintive moan,
And the dropping of the tear;—
His eye was fixed on the stirring sea,
Cold, darkly and severe!—

The boat was filled—the shore was left—
The farewell word was said—
But the vast crowd lingered still behind,
With an over-powering dread;
They feared that stranger and his bride,
So pale, and like the dead.

And many said that an evil pair
Among their friends had gone,—
A demon with his human prey,
From the quiet grave-yard drawn;
And a prayer was heard that the innocent
Might escape the Evil One.

Away—the good ship sped away,
Out on the broad high seas—
The sun upon her path before—
Behind, the steady breeze—
And there was nought in sea or sky
Of fearful auguries.

The day passed on—the sunlight fell
All slantwise from the west,
And then the heavy clouds of storm

Hidden History of Salem

Sat on the ocean's breast;
And every swelling billow mourned,
Like a living thing distressed.

The sun went down among the clouds,
Tinging with sudden gold,
The pall-like shadow of the storm,
On every mighty fold;—
And then the lightning's eye looked forth,
And the red thunder rolled.

The storm came down upon the sea,
In its surpassing dread,
Rousing the white and broken surge
Above its rocky bed;
As if the deep was stirred beneath
A giant's viewless tread.

All night the hurricane went on,
And all along the shore
The smothered cry of shipwrecked men
Blent with the ocean's roar;—
The gray-haired man had scarcely known
So wild a night before.

Morn rose upon a tossing sea,
The tempest's work was done;
And freely over land and wave
Shone out the blessed sun—
But where was she—that merchant-bark,
Where had the good ship gone?

Men gathered on the shore to watch
The billow's heavy swell,
Hoping, yet fearing much, some frail
Memorial might tell
The fate of that disastrous ship,—
Of friends they loved so well.

Literary Salem

*None came—the billows smoothed away—
And all was strangely calm,
As if the very sea had felt
A necromancer's charm,—
And not a trace was left behind,
Of violence and harm.*

*The twilight came with sky of gold—
And curtaining of night—
And then a sudden cry rang out,
"A ship—the ship in sight!"
And lo!—tall masts grew visible
Within the fading light.*

*Near and more near the ship came on,
With all her broad sails spread—
The night grew thick, but a phantom light
Around her path was shed;
And the gazers shuddered as on she came,
For against the wind she sped.*

*They saw by the dim and baleful glare
Around that voyager thrown,
The upright forms of the well known crew,
As pale and fixed as stone—
And they called to them, but no sound came back,
Save the echoed cry alone.*

*The fearful stranger youth was there,
And clasped in his embrace,
The pale and passing sorrowful
Gazed wildly in his face;—
Like one who had been wakened from
The silent burial-place.*

*A shudder ran along the crowd—
And a holy man knelt there,*

*On the wet sea-sand, and offered up
A faint and trembling prayer,
That God would shield his people from
The Spirits of the air!*

*And lo!—the vision passed away—
The Spectre Ship—the crew—
The stranger and his pallid bride
Departed from their view;
And nought was left upon the waves,
Beneath the arching blue.*

*It passed away—that vision strange—
Forever from their sight;
Yet, long shall Naumkeag's annals tell
The story of that night—
The phantom-bark—the ghostly crew,
The pale, encircling light.*

Emily Dickinson

Emily Dickinson has a tie to Salem in the person of Judge Otis Phillips Lord. Lord was appointed to the Massachusetts Superior Court in 1859 and from 1875 to 1882 served on the Supreme Judicial Court of Massachusetts. He lived in Salem.

Edward Dickinson, Emily's father, was a close friend of Lord, and Lord and his wife, Elizabeth, had often been their guests in Amherst. After Elizabeth died in 1877, Emily's relationship with Lord started getting romantic. She referred to him as "My lovely Salem," and passages in their letters indicate they were thinking of marriage. Despite her reclusive nature, Emily may even have been contemplating moving to Lord's home in Salem.

Unfortunately, his health began to decline before their plans could move forward. He died in 1884. She died two years later.

H.P. Lovecraft

Devotees of Yog-Sothothery already know H.P. Lovecraft's links to Salem. First on the list is Arkham, the site where many of Lovecraft's stories take place. Arkham *is* Salem.

According to Charles P. Mitchell in *The Complete H.P. Lovecraft Filmography*, "Lovecraft based Arkham on Salem, Massachusetts, in the identical geographical location." August Derleth named his publishing company Arkham House "since it was Lovecraft's own well-known, widely-used place-name for legend-haunted Salem, Massachusetts, in his remarkable fiction."

Even if you didn't already know this, you can tell from the way Arkham is described:

> *Then he went back to Arkham, the terrible witch-haunted old town of his forefathers in New England, and had experiences in the dark, amidst the hoary willows and tottering gambrel roofs, which made him seal forever certain pages in the diary of a wild-minded ancestor.*
> —The Silver Key

> *He was in the changeless, legend-haunted city of Arkham, with its clustering gambrel roofs that sway and sag over attics where witches hid from the King's men in the dark, olden years of the Province.*
> —The Dreams in the Witch House

> *[M]uch was made of the traditions of horror, madness, and witchcraft which lurked behind the ancient Massachusetts town then and now forming my place of residence* [Arkham].
> —The Shadow Out of Time

Arkham is peopled with Pickmans, Curwens, Uptons, Derbys and Crowninshields. At least two narrators live on Saltonstall Street. All of these are good Salem names.

Sometimes the pseudonym of Arkham is dispensed with:

> *So at length Carter crawled through endless burrows with three helpful ghouls bearing the slate gravestone of Col. Nepemiah Derby, obit 1719, from the Charter Street Burying Ground in Salem.*
> —The Dream-Quest of Unknown Kadath

The Charter Street Burying Ground in Salem. *Patrick Stanbro, www.patrickstanbro.com.*

Literary Salem

You know Pickman comes of old Salem stock, and had a witch ancestor hanged in 1692.
—Pickman's Model

And the glory of Salem's towers and spires seen afar from Marblehead's pastures across the harbour against the setting sun.
—The Dream-Quest of Unknown Kadath

Even the Essex Institute, now the Peabody Essex Museum, makes an appearance:

At the Essex Institute, which was well known to him from former sojourns in the glamorous old town of crumbling Puritan gables and clustered gambrel roofs, he was very kindly received, and unearthed there a considerable amount of Curwen data.
—The Case of Charles Dexter Ward

House of the Seven Gables. *Courtesy of Library of Congress, HABS MASS,5-SAL,16-6.*

And there's more. The links to Salem go even deeper than places and names. H.P. Lovecraft considered Hawthorne's *The House of the Seven Gables* "New England's greatest contribution to weird literature." It inspired his *The Case of Charles Dexter Ward*. This wasn't Hawthorne's only influence on him, either. According to *An H.P. Lovecraft Encyclopedia*, *The Unnamable* was inspired by Hawthorne's *Dr. Grimshawe's Secret*. It is the Grimshawe house that sits hard upon the Charter Street burying ground, precisely as it is described in *The Unnamable*:

> *We were sitting on a dilapidated seventeenth-century tomb in the late afternoon of an autumn day at the old burying-ground in Arkham, and speculating about the unnamable…Our seat on the tomb was very comfortable, and I knew that my prosaic friend would not mind the cavernous rift in the ancient, root-disturbed brickwork close behind us, or the utter blackness of the spot brought by the intervention of a tottering, deserted seventeenth-century house between us and the nearest lighted road. There in the dark, upon that riven tomb by the deserted house, we talked on about the unnamable.*

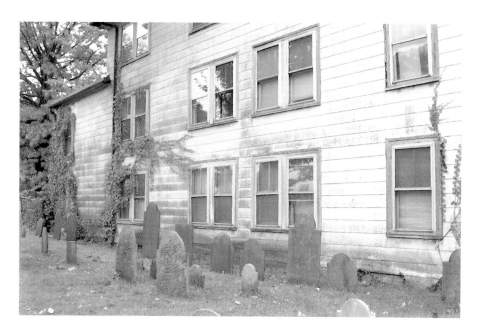

Dr. Grimshawe's House and site of *The Unnamable*.

Literary Salem

Although Arkham is the scene of many terrifying happenings and is practically a character itself in *The Thing on the Doorstep*, in Lovecraft's writing the town is portrayed as neither evil nor intrinsically frightening. Arkham represents the safety our narrator is trying to reach in both *The Shadow Over Innsmouth* and *The Picture in the House*. Even more telling, when Randolph Carter goes in search of the marvelous city of his dreams in *The Dream-Quest of Unknown Kadath*, his friend Kuranes warns him,

> *At the last, he was very certain,* [Carter] *would long only for…the glow of Beacon Hill at evening, the tall steeples and winding hill streets of quaint Kingsport* [Marblehead], *the hoary gambrel roofs of ancient and witch-haunted Arkham, and the blessed meads and valleys where stone walls rambled and white farmhouse gables peeped out from bowers of verdure.*

Perfection can't hold a candle to New England, Arkham included.[55]

Edible Salem

Salem has always liked coffee. Back in the day, coffeehouses were like clubs. Men went there to write letters, transact business, talk politics, play cards, read newspapers and gossip. Yes, coffee was a manly drink.

But coffeehouses offered more than just coffee.

A 1773 advertisement for Salem's London Coffee House, founded in 1698, reads, "English magazines and a variety of newspapers will be procured for the amusement of [proprietor Ephraim Ingalls's] respectable customers." Salem's Sons of Liberty would meet here, read the news from England and drink toasts to the destruction of the Stamp Act. Yes, at least in America, you could find other beverages at a coffeehouse besides coffee.[56]

In America, coffeehouses were often hotels, as well. Traveling performances could be seen there. You could even have your packages delivered to your favorite coffeehouse and pick them up when you went in for a cuppa.

As drinking tea became unpatriotic, more and more Americans started imbibing coffee. In Salem, coffee became one's traditional breakfast drink, which meant that coffee was highly in demand. On April 28, 1777, William Pynchon records in his diary there was "a scramble at the wharf in weighing out and selling Capt. Derby's coffee." Do not get between a deprived coffee drinker and his bean.

About 1804, Captain Joseph Ropes, in his ship the *Recovery*, brought the first cargo of coffee from Mocha in an American vessel to Salem. The first cargo of Brazilian coffee in an American ship, the *Marquis de Someruelas*, came to Salem, too, in 1809. This was 1,522 bags of Brazilian coffee. That was not a record, however. In 1808, the ship *Franklin* brought a cargo of

Edible Salem

532,365 pounds of coffee. The custom duties on this amount of coffee totaled $26,618.25.

Caroline Howard King remembered:

> *An old Salem sea-captain had presented my father with a bag of the choicest variety* [mocha], *and it was only used on great occasions, enriched by cream so thick that it had to be taken from the cream pitcher with a ladle, and by the sparkling loaf sugar of those days, and served hot and fragrant, in my grandmother's delicate old India china mugs.*

Along with their coffee, Salemites liked candy. According to tradition, an Englishwoman named Spencer and her son were stranded in Salem, and in an effort to provide for her family, she experimented with making candy. The result she named a Gibralter. Yes, spelled that way.

It was immediately popular. Business grew so that Mrs. Spencer bought a wagon to drive from shop to shop, supplying Gibralters to her wholesale customers. Gibralters were wrapped in "soft white paper" and "when fresh were almost as hard as their Spanish namesake, losing the brittle quality in course of time, but never melting into stickiness. The retail price was a silver four-pence half-penny for seven, and many a child used to spend his or her whole allowance in the purchase of the tempting sweets." Salem Gibralters turned out to be one of the city's most beloved exports and were known in far corners of the world, thanks to Salem's wide-ranging ships.

In 1860, it was assumed everyone was familiar with Gibralters. In "Yet's Christmas Box," a story in *Harper's New Monthly Magazine*, one of the characters is described thus: "Altogether, her appearance was that of half an enormous stick of candy, or rather, a flattened *gibralter.*"

In 1900, a lady from Iowa wrote in to *Everyday Housekeeping* inquiring about Salem Gibralters. The magazine responded:

> *The formula is supposed to be private property but I have no doubt skillful confectioners could duplicate the candy. In appearance it seems to be like any common boiled sugar candy, in many places called cream candy. It is not worked smooth, but left in a somewhat rough strip about three inches wide and one inch thick, and is evidently cut when warm into pieces about one inch wide, and almost on the bias so to speak. A narrow stripe of candy of a different texture runs through the middle. Each piece is wrapped in paper, and marked either lemon or peppermint according to the flavor. Black*

> *Jack is another variety of candy, somewhat like old fashioned molasses and hoarhound stick candy, made by the same firm.*

Black Jacks, another Salem native made with black strap molasses, did not garner so wide a reputation. One Victorian customer speculated that while Salem children adored Black Jacks, they had "too strong a flavor of liquorice, too haunting a medicinal suggestion to be loved by other children of the Puritans."

Eleanor Putnam described Black Jacks so:

> *In tasting Black-jack you imagine that you detect a hint of maple syrup, a trace of butter, a trifle of brown sugar and molasses, and a tiny fancy of the whole mixture's having been burnt on to the kettle. Make no mistake, however. This burnt flavor is not accidental, but intentional. It is one of the mysteries, not particularly pleasant perhaps, but it is the correct Black-jack flavor, and no Black-jack worthy of the name would consent to be without it. To the youthful palate Blackjack possesses a taste at once sweet and bitter, rich and slightly medicinal, but altogether joyous and delightsome.*
>
> *Black jack decidedly has not that air of exclusiveness which marks the Gibralter. Black-jack has about it a reckless and somewhat riotous devil-may-carishness. It is preeminently the joy of the youthful. It satisfies young ambition. It fills all one's desires as to stickiness and sweetness. It is of convenient size if one be generously disposed to offer bites. It is a consoler of grief, and a sympathizer in time of joy.*

Eleanor describes Gibralters:

> *The Gibralter, on the other hand, is a white and delicate candy, flavored with lemon or peppermint, soft as cream at one stage of its existence, but capable of hardening into a consistency so stony and so unutterably flinty-hearted that it is almost a libel upon the rock whose name it bears. The Gibralter is the aristocrat of Salem confectionery. It gazes upon chocolate and sherbet and says: —*
>
> *"Before you were, I was. After you are not, I shall be."*

Her conclusion:

> *In spite of their differences of constitution, however, Black-jack and Gibralter are firm friends, united by the bonds of age and long*

Edible Salem

companionship. Together they have lived. Together they have rejoiced the souls of generations. Witch Hill may blow away; the East India Museum may be swallowed up in earth; Charter Street Burying Ground may go out to sea; but as long as a single house remains standing in Salem Village, so long will Black-jack and Gibraltar wisely reign, and retain their honorable place in the inmost hearts of the Salem people.

Both Black Jacks and Gibralters are still available in Salem at Ye Olde Pepper Companie, America's oldest candy company, founded in 1806. It even has some of its original, almost two-hundred-year-old Gibralters in a giant glass jar that, no, you can't eat—although odds are they're still unspoiled.

Another treat native to Salem were cockles:

And last, the playful Squire commanded
A plate of cockles to be handed;
Those sugar cockles tightly rolled
Did each a sentiment enfold.
"It mattered not" the Squire said
"That he was elderly and wed.
He liked the mottoes to unwind
Some bit of sentiment to find!"

Cockles were described as "tiny cornucopias of sugar, white and colored, each containing a couplet, expressive of a tender sentiment, printed on a slip of paper." It was sort of a sugar fortune cookie, with only romantic thoughts inside. The author of the poem, Mary Saltonstall Parker, believed cockles were not found outside of Salem, as they were only made by one French confectioner in town.

I have dug up the following recipes, all of which pertain to Salem, for your reading pleasure. And your cooking pleasure, if you wish to be adventurous. I haven't attempted any of them, so I can't say how they'll turn out.

To be eaten for breakfast on The Glorious Fourth (of July)—
Salem Muffins—
One and one-half cups of flour, half cup of cornmeal, one teaspoonful of sugar, half teaspoonful of salt, one heaping teaspoonful of baking powder, one level tablespoonful of butter, two eggs, and one cup (full measure) milk,

half teaspoonful of cinnamon. Sift together flour, cornmeal, salt, sugar and baking powder; rub in the butter, add the eggs, well beaten, milk and cinnamon. Have the griddle well heated, grease it, lay on it the muffin rings, also greased, and half fill them with the batter. As soon as risen to top of rings, turn them over gently with cake turner; bake nice brown on both sides. They should bake in seven minutes.
—Chicago Daily News *1896*

When one ate one's pudding was of political significance in Salem. Federalists ate their puddings first. Jeffersonians ate their puddings at the end of their meal. One can assume Caroline Howard King's family were Federalists because she writes, "In my grandfather's house the pudding was served first." Pudding is today considered a dessert, eaten at the end of the meal, so the Jeffersonians seem to have won.

Here are some Salem puddings:

Salem Pudding
3 cups flour, 1 cup milk, 1 cup molasses, 1 cup chopped suet, 1 cup raisins chopped fine, ½ teaspoon saleratus[57] or 1 teaspoon soda put into the molasses. Boil in a pudding boiler four to five hours.

Salem Plum Pudding
A Pound of bread, a quart of boiled milk, eight eggs, a spoonful of flour, a teacup of sugar, one nutmeg, a teaspoonful of pounded clove, two ounces of butter, four of chopped suet, and a pound of raisins.

This recipe for a Sally Lund tea cake can be found in *What Salem Dames Cooked*. What's particularly intriguing about this is that Sally Lund buns are famously from Bath, England. Sally Lund came to Bath in 1680, a Huguenot refugee. Her bread became *the* English delicacy, just as Bath became *the* place to be seen in Georgian England. The recipe for Sally Lund buns—still for sale in her house in Bath, by the way—is a close-kept secret, so it is interesting that Salem came up with its own Sally Lund recipe.

Sally Lund (Tea Cake)
1 qt. flour, 2 eggs, 1 pt. milk, butter size of an egg, ½ teacup sugar, ½ teaspoon salt, 2 teaspoons cream tartar, 1 teaspoon soda. Bake in shallow pans and cut in squares.

Edible Salem

Then there are the cakes. Salem seems to have lent its name to several cakes, including one named after our famous mathematician and founder of modern maritime navigation, Nathaniel Bowditch.

Salem Cup Cake
Take 1½ cup butter, 3 cups sugar, 5 eggs, 1½ cup milk, 4½ even teaspoons baking powder, 4½ cups pastry flour, lemon and nutmeg. Cream butter, add sugar, yolks of eggs well beaten and milk. Add flour gradually, with baking powder sifted into flour; add flavoring. Beat well, then fold in the stiffly beaten whites of eggs. Bake in moderate oven.

Salem Cake
Three even pint bowls of sifted flour, two of sugar, half a pound of butter, one great spoonful of lard, five eggs, one great spoonful of saleratus, three nutmegs, and salt to taste; caraways if you please. Mix butter, lard, and sugar together, pour the eggs to the butter, and add the flour and nutmegs. Roll very thin, cut with a form, and bake.

Salem Wedding Cake
Ten pounds of flour, ten of sugar, ten of butter, twelve of currants, four of raisins, seventy eggs, a pint of best Malaga wine, three ounces of nutmegs, two of cinnamon, two of mace, a heaping teaspoonful of powdered clove, two pounds of citron.

Bowditch Cake
Three pounds of flour, one of butter, half a pound of sugar, nine eggs, a little saleratus dissolved in milk.

Rose Cake (Rantoul recipe)
¾ lb. sugar, ½ lb. butter, 4 eggs, a little rose water, 1 lb. flour; spread with a knife as thin as possible on tins, bake a very light color, mark it in squares immediately on taking it out of the oven.

Back in the day, Salem was known for gingerbread. Molly Saunders was said to make the best, her secret being that she boiled her butter in molasses. In Molly's shop, the upper-shelf gingerbread cost three cents and the lower-shelf gingerbread cost two cents.

Molly Saunders's Gingerbread
Lower Shelf:
3½ lbs. flour, 1 lb. butter, ½ pt. milk, 1 qt. molasses, 2 teaspoons saleratus, 2 tablespoons ginger. Make one day and bake the next.
Upper Shelf:
2 lbs. flour, ½ lb. butter, 3 eggs, ¾ lb. sugar, 1 nutmeg, ½ cup milk, 1 teaspoon saleratus. Add flour lastly and it will not usually require the full amount. Make one day and bake the next.

Salem Sugar Gingerbread
Four pounds of flour, two of butter, three of sugar, fifteen eggs, and a teaspoonful of saleratus, dissolved in half a gill of rose-water, or wine. To be baked in deep pans. This keeps a long time, and no gingerbread can be better.

Zanzibar Gingerbread
12 lbs. flour, 8 lbs. sugar, 6 lbs. butter, 18 eggs, ½ pint rosewater, teacupful ginger, 6 teaspoons saleratus.

Salem side dishes:

Corn Dodgers (Salem recipe)—One pint of cornmeal, one tablespoonful of melted butter, salt to taste. Scald with boiling water, and beat quick and hard for five minutes; then drop from a large spoon on a buttered baking-sheet. Your batter should be just thick enough to flatten on the bottom, the cakes being quite high in the middle. Bake in a hot oven.

Salem Fritters
Beat six eggs with one pint of cream, four ounces of sugar, one glass of wine, half a nutmeg, as much flour as will make a nice batter. Fry in lard.

Squash Pudding (from Salem's Mrs. Devereux)
1 qt. fine squash, 1 qt. milk or cream, 16 eggs, 1 lb. butter, 1¼ lbs. sugar, 2 nutmegs, 4 spoonfuls rose water, 2 to 4 groat biscuit.

Edible Salem

Salem main course:

Salem Harbor Dish
Cut the fat from your beef, and fry it out; slice four onions, and fry them also. After taking up the onions, fry the meat in the same fat about twenty minutes. Add salt, pepper, and flour. Cover it with just enough water to make a rich gravy when done, allowing for the boiling away of the water. Add crackers or not, as you please; it is nicer with. It requires three hours' cooking.

Just in case you ever wondered how ice cream was made at home at the turn of the last century:

Strawberry Ice Cream
2 qts. of strawberries covered with 2 cups of sugar and left over night, or at least four or five hours. Mash and strain berries, then add 1 qt. of cream and freeze.

Maple Sugar Ice Cream
To a scant cup of rich maple syrup add beaten yolks of 4 eggs and cook, stirring until it boils. Strain through sieve and cool. Beat 1 pt. cream, add beaten whites, and whip syrup until light. Mix together and freeze.

And for the adventurous, or downright crazy, Alice Morse Earle describes this Salem beverage:

A terrible drink is said to have been popular in Salem. It is difficult to decide which was worse, the drink or its name. It was sour household beer simmered in a kettle, sweetened with molasses, filled with crumbs of "ryneinjun" bread, and drunk piping hot; its name was whistle-belly-vengeance, or whip-belly-vengeance.

You might want to just stick with coffee.

Cats of Salem

Freida was a very happy and fortunate cat. Her mistress was born in good old Salem, and, like all the people in that bewitching place, she thought a home was not perfect without the family cat.
—Miranda Eliot Swan

Ghost Cats

For the Halloween capital of the world, Salem's ghost population is surprisingly small. And furry. Yes, two feline spirits have made Salem their permanent home. The most famous is the Daniels House cat.

The Daniels House, a three-story, wood-frame and clapboard building, was built in 1667 for Captain Stephen Daniels. The southern half of the lower two stories is the oldest part of the house, which was enlarged in 1756 by Daniels's great-grandson Samuel Silsbee. No one knows where the cat comes in, although for a house in Salem to exist almost 350 years *without* a cat would have to be some sort of minor miracle. In any case, guests have repeatedly commented on the tabby, only to be told the inn has no cats.

Our other ghostly cat haunts the Witch House. The Witch House bears this name because Jonathan Corwin, one of the witchcraft trial judges, purchased the house in 1674, and during 1692 many of the examinations of witnesses and accused were held here. So one might expect an apparition from those times. Instead, we have a cat.

Cats of Salem

The Daniels House. *Patrick Stanbro, www.patrickstanbro.com.*

Cats have a special place in Salem. Each year there is an Official Cat of Salem contest.

In 1897, international photographer Walter Sprange was photographing the rear of the Witch House because, despite the modern buildings that surrounded it at the time, "the rear view of this house still affords a very characteristic specimen of an old-fashioned New England back door." Sprange wrote articles on photography covering both how and where to photograph, and this was to illustrate his article on Salem.

> *Three plates were exposed at the time this view was taken. In the view presented one of the most woe-begotten, ill-shaped cats (*a relic, no doubt, left by some of the witches*), may be seen peering out of the open casement; in another view taken it appears in the doorway; in taking these two views the presence of the cat was not observed, but in a third view, taken especially to include the cat, then noticed for the first time in the projecting shelf over the door, it does not appear at all.*

Unfortunately for those of us who wish to see the ghost kitty, Sprange illustrated his article with the one photograph in which the cat does not appear. He did have a serious reputation to uphold, I suppose.

Real Cats

Then there are the real cats of Salem. Nathaniel Hawthorne loved cats, "cats being his special pets." "When tired of reading he would construct houses of his books for his pet cat, building walls for her to leap, and triumphal arches for her to pass under."[58]

Another apparent cat lover was Giles Corey. Before being accused of witchcraft himself, he named his wife Martha as a witch. One of his reasons for this was that he believed she had bewitched his cat with the intent of getting him to kill it: "I had a Cat sometime last week strangely taken on the sudden and did make me think she would have died presently. My wife bid me knock her in the head but I did not and since she is well."

The most famous cat of Salem is Pompey, first cat to cross the Atlantic in the first American yacht. *Cleopatra's Barge* was a wonder of craftsmanship and expense. On December 6, 1816, Dr. Bentley described it in his diary as being "fitted for sea in a manner never before observed in this Town."

Cats of Salem

Her model is excellent and her naval Architecture the best. The rigging is in the highest improvement as to its form and complete and of the best materials and workmanship. The best patent horizontal windlass with two stations just aft of the foremast. A rudder fixed to move with great ease and safety upon a new patent. The belaying pins of the Mast of brass. Below is the berth for the officers. Next is the dining-room finished of the best materials and furnished with the best carpets, elegant settees with velvet cushions, chairs with descriptive paintings, mirrors, buffets loaded with plate of every name, and the best glass and porcelain. Adjoining are the berths for the owner and passengers with apartments having all the articles for the ship assigned to their own particular vessels and beyond about midship the kitchen with all the necessary furniture for all its purposes. In the forepart of the vessel are the berths of the seamen. The expense must have been very great but the aid to improvement and enquiry is great and extensive. Nothing has been suffered to enter not in the highest style of excellence. I should have been very glad to have had an inventory of the contents of this vessel.

Some of the ropes on the quarterdeck were decorated with velvet. The wood for her furniture and fittings was mahogany and bird's-eye maple. There were gilt mirrors, gilt eagles and gold lace, along with red velvet upholstery and a chandelier.

Nothing had been made nor seen like it before, and everyone wanted to experience *Cleopatra's Barge* for himself. To say that *Cleopatra's Barge* had many visitors would be an understatement—for two weeks attendance averaged over 900 per day. On one day, George Crowninshield Jr., its owner, counted 1,900 women and 700 men. One such visitor wrote: "The sleeping room is very pretty, the hangings of the bed a rich variegated yellow patch, full curtains and handsome fringe. We found a yellow cat lying on the bed; the captain said she came on board of her own accord, and had chosen her position, and he intended to take her with him for good luck."

Here on the large four-postered, canopied bed, we meet our ship's cat. His name was Pompey. Hannah Crowninshield's drawing, hanging in the Peabody Essex Museum, depicts Pompey with stripes, so perhaps he was a yellow tiger cat.

Pompey chose to be on this historic voyage to the Mediterranean, but unfortunately he didn't make it back. Below her drawing of him, Hannah wrote:

In Memory of
Pompey
Who became a Victim to his Patriotism
In 1817.

Hannah was the daughter of Benjamin Crowninshield, captain of the *Cleopatra's Barge*. Pompey was his cat. Even Crowninshield cats took their duty to posterity seriously.

All that Remains…

Salem almost didn't happen.

The colonists who arrived here had actually come from Cape Ann, and Plymouth before that. They left Plymouth for various reasons, some strictly for profit in setting up a new planting, fishing and trading venture and some because they did not get along with the separatist ways of the Plymouth pilgrims. This group that left Plymouth would become the core of the colonists we know as Puritans. They wished to purify the Church of England rather than separate from it.

Unfortunately, the Cape Ann enterprise failed, and in 1626, Cape Ann was abandoned. Some of the settlers left for England at this point, but the Puritans didn't give up so easily. For one thing, they didn't have anywhere else to go. They didn't get along with the people at Plymouth, and they certainly didn't get along with England's state church, so the remaining twenty-five settlers sailed southward along the coast, looking for another location to set up a viable community.

They landed at a place called Naumkeag. Yet again, the settlers carved a little village out of the wilderness. However, dissatisfaction with their situation soon arose. Life was hard, and now with winter coming it would get even harder. Relations with the local Indians were uncertain, and perhaps the already settled Virginia colonies would be more profitable. Their temperate climate would undoubtedly be more comfortable. But they hadn't reckoned on Roger Conant.

Roger Conant, committed Puritan and leader of the settlement, wasn't about to give up on Naumkeag. Not only had he personally selected it as

their landing site, but he also hoped the settlement would become a haven for future Puritan emigrants. The Puritans would lose their foothold in the New World if Naumkeag collapsed now. So Conant took a stand. In his own words, "I was a means, through grace assisting me, to stop the flight of those few that then were here with me, and that, by my utter denial to go away with them who would have gone either for England or mostly for Virginia, but there-upon stayed to the hazard of our lives."

Or, to put it another way, "Yes, though my colonists would have preferred to return home to England or, failing that, to seek out a cushy place in the warm climate of Virginia, I thwarted those dreams and made them risk their lives staying here with me." An evil laugh would probably not be out of place at this point.

Conant and his "I kept them here" quote.

All that Remains…

One assumes Conant had a persuasive tongue, although the fierce statue of him glowering toward Salem Common might make one wonder what other means of persuasion he used. Indeed, he has been mistaken for a warlock by visitors who failed to read the plaque on his plinth.

Said statue may also lead you to think he was a crotchety old man at the time of Naumkeag's founding. In actuality, he would have been about thirty-four years old. This doesn't mean he didn't rock the evil laugh, of course.

Salem, brought to you by the letter S, for stubbornness.

There are others who, like Conant, refuse to leave Salem. Some of them continue in this conviction even after death. Yes, we're talking about ghosts.

Haunted Salem

The ghost cat of the Daniels House has already been mentioned. However, the Daniels House is not the only place in which a visitor can experience paranormal phenomena right where they're staying. The Salem Inn[59] is supposed to have unusual energy in its breakfast room, and the Hawthorne Hotel[60] is said to have several non-paying guests.

The Lyceum Bar and Grill is associated with Brigit Bishop, first to be executed during the witch trials, and the scent of apples from her orchard still lingers, along with unusual energy that plays havoc with electrical equipment. Murphy's Irish Pub is also said to be haunted, not surprisingly, for it sits practically on top of the Old Charter Street Burying Ground. Murphy's ghost is said to be a young girl named Mary, who was buried close to the cemetery wall. Notice how Salem ghosts tend to stay where good times can be had.

For a scenic place where spirits might be found, try the Ropes Mansion, supposedly haunted by Abigail Ropes. She is said to have walked too close to her bedroom fireplace and the skirt of her nightgown caught fire. Some claim her ghostly figure roams throughout the mansion.[61]

Salem's Howard Street has a reputation of being quite haunted, although this might be simply because it runs the length of Howard Street Cemetery. The ghost of Giles Corey is said to haunt here, this being the field where he was pressed to death. Tradition holds that with his dying breath Corey cursed Salem and its sheriff.

Apparently there is evidence that the job of sheriff does come with this built-in occupational hazard. Former high sheriff of Essex County Robert

Ellis Cahill discovered that each sheriff from George Corwin—the sheriff who executed the squashing of Corey—all the way down to himself had either died in office or been forced to retire due to a heart or blood ailment. The ghost of Giles Corey is also said to appear before a time of devastation for Salem. Forty people reported that they had seen him before the Great Fire of 1914 burned two-thirds of Salem to the ground.

George Corwin's house is also haunted. Whether the spirit here is Corwin himself or whether a ghostly record of the terrible inquisitions perpetrated here has burned its way into the building's aura is anybody's guess, but the house that now stands where his once did, the Joshua Ward House, is considered one of the most haunted houses in America.

President George Washington slept at the Joshua Ward House on October 29, 1789.[62] It's not his presence you have to fear, however. Because of the witch trials, George Corwin made many enemies, not only among the families of those he executed but of the accused as well. At this time, once proceedings had begun against you, the law could confiscate your possessions. Even if you were later cleared, you didn't necessarily get all your belongings back. Corwin took a lot of people's stuff.

One of the many victims of this practice was Philip English. English and his wife had been accused of witchcraft but wisely fled. When the witch-hunting frenzy had died down, they returned to find that Corwin had emptied their house. Now, Philip English could hold a grudge. He only forgave Judge Hathorne[63] on his deathbed and even qualified that with the remark that, if he got better, "be damned if I forgive him." English wanted his stuff back from Corwin. Some of it he got. Some he didn't.

So when Corwin died, his family feared what would happen to his body. One of his many enemies might desecrate it. But only if they beat Philip English to it, as there was a very good chance English would abscond with the body and hold it for ransom. The family couldn't risk his body leaving his house.

So they buried Corwin in the basement.

He stayed there several years before eventually being moved to Broad Street Cemetery. Or did he never really leave? Reports of candles having been bent and twisted, objects having moved on their own and the security alarm going off more than sixty times within two years might give one pause.[64] There have been sightings of a female apparition, as well.

The ghost cat of the Witch House has previously been noted. There might be more spirits. The southeast room on the ground floor supposedly

All that Remains…

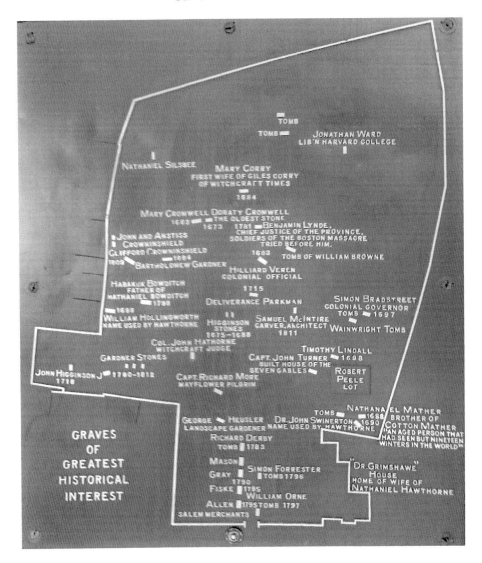

Guide to the Charter Street cemetery's Graves of Greatest Historical Interest.

witnessed witch "examinations." Also, the house is located on a ley line,[65] according to paranormal researcher Fiona Broome. This energy might make apparitions more active.

However, considering the number of cemeteries in Salem, the vast majority of the dead seem quite content not to wander. Visitors will have to come to them. To this end, there is a directory posted at the gate of the Charter Street Burying Ground.

The Charter Street Burying Ground is the oldest of Salem's cemeteries. Visiting Englishwoman Emily Soldene described it:

Why, the scene is English, quite English, full of trees, such old, old trees, and the chilly and moaning winds creep sadly through them, the dry leaves rustle and rattle, and drop slowly and wistfully and reluctantly to the ground; there are little heaps of yellow and brown and faded red ones, drifted against the sheltering corners of the crooked and leaning and mossy gravestones, which the tall, rank, tawny and grey coarse grass (tall as harvest ripe wheat) clasps so closely, so lovingly, and to me there seems a movement and a shiver among them, as I, a stranger in the land, intrude on this domain.

You can learn many things from Salem headstones. Like the fact that *Mayflower* passenger Richard More, one of the original Plymouth pilgrims, is buried here, as is his wife. At first glance, it looks like her name has been left off in favor of asserting her goodness and to whom she belonged: "Christian wife to Richard More." Actually, there should be a comma between the *n* and the *w*. Her maiden name was Christian Hunter (or Hunt).

Charter Street cemetery, also known as the Old Burying Point, the oldest cemetery in Salem. Started in 1637.

All that Remains…

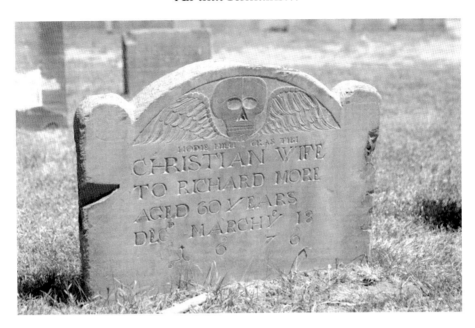

The Latin on this tombstone, *hodie mihi, cras tibi*, means: "It is my lot today, yours tomorrow." Be warned. *Patrick Stanbro, www.patrickstanbro.com.*

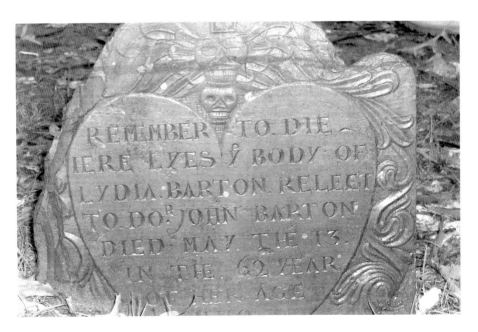

Memento Mori. Now don't forget.

Advice can also be found cut into slate. For example, "Remember to Die." Put it on your to-do list now so you don't forget. Go on. I'll wait.

Odd—or amusing—as you might find it, "remember to die" is one of the translations of "memento mori." Another way to translate the famous phrase is "remember you are mortal." When spoken to Caesar, it means don't get above yourself. When on a tombstone, it means make sure you're right with God because you never know when you might be hit by a bus.

Salem being a port city, there are also stories of the sea to be found amongst the gravestones. One such tale is of the Crowninshield ship *Brutus*, which sailed from Salem on a beautiful Sunday morning, February 21, 1802, only to be wrecked on Cape Cod in a "terrible snow storm" the next day. This storm took Salem's *Ulysses* and *Volusia*, too.

Most of the *Brutus*'s men survived the shipwreck but died on the snow-covered land of exposure, frozen in the subzero temperature and unceasing gale winds. According to Dr. Bentley's diary, Captain Browne was buried outside of Provincetown, near where he died. He has a headstone in Salem, though. Was his body later moved? Or is this only a marker?

Captain Browne had been about to marry a Salem girl named Priscilla Webb. Distraught at his death, Priscilla "kept to her first love" and never married. She lived to be eighty years old. At least she had a local monument to bewilder with roses.[66]

The eighteenth-century custom of giving gloves away at funerals extended into the nineteenth century in Salem, as did giving away mourning rings. Even though it could be quite an expense, Salem loved mourning rings. Eleanor Early says "there was a particular vogue in Salem for these mourning rings." Alice Morse Earle describes them:

> *These mourning rings were of gold, usually enameled in black, or black and white. They were frequently decorated with a death's-head, or with a coffin with a full-length skeleton lying in it, or with a winged skull.*
>
> *Sometimes they held a framed lock of hair of the deceased friend. Sometimes the ring was shaped like a serpent with his tail in his mouth…*
>
> *A favorite motto for these rings was: "Death parts United Hearts." Another was the legend: "Death conquers all." Another, "Prepare for Death." Still another, "Prepared be To follow me."*
>
> *Other funeral rings bore a family crest in black enamel. Goldsmiths kept these mourning rings constantly on hand. "Deaths Heads Rings" and "Burying Rings" appear in many newspaper advertisements. When bought*

All that Remains...

Gravestone of Captain William Browne of the Crowninshield ship *Brutus*.

for use the name or initials of the dead person, and the date of his death, were engraved upon the ring. This was called fashioning.

You may still find rings with coffins and skeletons in Salem. As you will have noticed, there are many ties between contemporary Salem and its past. Even the modern Salem hospital is supposed to be haunted. Which part, you may wonder? The delivery room.

Apparently the ghosts of Salem like to welcome new residents.

Notes

Ensorcelled Salem

1. *Putnam's Monthly Historical Magazine*, "The Proposed Memorial 'Look Out' On Gallows Hill, Salem," (March 1893): 296.
2. Ibid.
3. This is probably psoriasis, although the term sometimes meant herpes.
4. This was Giles Corey. His mode of death was different because he refused to answer the charge.
5. John Willard had been deputy constable of Salem Village until he began to question the truth of the afflicted girls' accusations. Toward the end of April 1692, he refused to arrest any more witches. Upon hearing this, the girls cried out against him. On May 10, a warrant was issued for his arrest and he was found guilty of witchcraft. He was hanged alongside Reverend George Burroughs, Martha Carrier, George Jacobs Sr. and John Proctor.

The Myrmidons of Colonel Leslie

6. The number of troops on this expedition varies from 200 to 500, depending upon whom you read. Historian B.F. Stevens cites one of Gage's letters as having "two hundred" written out, so there can be no mistaking the numerals, which should be fairly definitive. On the other hand, eyewitness Elisha Story of Marblehead said 246.

7. This is generally translated as "They fear not hardship." However, it can also be translated as "Undaunted by difficulties." And even "Difficulties be damned." Latin is fun that way. Robert S. Rantoul, "How Many Men Had Leslie at North Bridge," *Essex Institute Historical Collections* 32, nos. 1–6 (1896): 22–23.
8. Given the historical rivalry between England and Scotland, one can't help but wonder if Leslie corrected Felt with the news that he was Scottish.
9. Leslie and his regiment were not part of the Battle of Bunker Hill either.

A Country Called Salem

10. Duane Hamilton Hurd, ed., *History of Essex County, Massachusetts* vol. 1 (Philadelphia: J.W. Lewis & Co., 1887), 86.
11. Ralph Delahaye Paine, *The Ships and Sailors of Old Salem* (Chicago: A.C. McClurg & Co., 1912), 84.
12. Ibid., 89–90.
13. Salem is located in Essex County.
14. The *Essex* carried among its crew a midshipman named Farragut, who would later become a hero of the Union navy and an admiral. He's the guy who is quoted as saying, "Damn the torpedoes, full speed ahead!"
15. A Boston vessel had visited Japan in 1799—with a Salem captain, James Devereux.
16. You know the *Grand Turk* today because it is the ship on Old Spice toiletries.
17. Samuel Eliot Morison, *The Maritime History of Massachusetts, 1783–1860* (New York: Houghton Mifflin, 1921), 80.
18. Robert S. Rantoul, "Some Claims of Salem on the Notice of the Country," *Historical Collections of the Essex Institute* 32, nos. 1–6 (1896): 21
19. This flag started out with twenty-four stars and was then updated in 1861 to thirty-four stars, plus a white anchor signifying Driver's years at sea.

Fallen Angel

20. George Crowninshield Jr. had his portrait painted by Samuel F.B. Morse. Yes, the Morse Code guy.
21. *Cleopatra's Barge* was built by the famous Retire Becket. The Becket family built ships in Salem for over 150 years.

22. At the time, there were rumors that George Jr. intended to use this voyage to rescue Napoleon from St. Helena.
23. Although labeled insane at the time, it sounds more like he had Tourette's syndrome.
24. His mother was Irish. She had been deemed an inferior match by the extended family, one of whom commented that Irish heritage "certainly showed" in her children's appearance. (This was considered A Bad Thing.)
25. His poem concludes with the coda: "Sarah this is the way I beguile my sluggish time; by promiscuously patching together imperfect rhymes."
26. Nothing says cool like giving the *Mystery Science Theater 3000* treatment to your own capital trial.

Surprising Salem

27. In 1844, Salem became the first city in Massachusetts to integrate its schools.
28. While there, Remond demonstrated against the convention's refusal to recognize women as delegates.
29. Slaves fleeing on the Underground Railroad had two routes to choose from when leaving Salem—north to Canada via New Hampshire or along the coast via Maine.
30. Robert Gould Shaw was the Bostonian commander of the Fifty-fourth Regiment who was killed in action at Fort Wagner.
31. For a mental image, remember that Shaw was played by Matthew Broderick in the movie *Glory*.
32. As to how his body was disposed of, the Rebel commander said, "Had he been in command of white troops, I should have given him an honorable burial. As it is, I shall bury him in the common trench, with the negroes that fell with him." If anyone had asked Shaw, he probably would have said that was honor enough.
33. Francis was twenty-eight years old at the time of their marriage.

Salem's Chinese God

34. Robert S. Rantoul, "Frederick Townsend Ward," *Essex Institute Historical Collections* 44, no.1 (January 1908): 17.
35. Richard Crowninshield Jr. attended Norwich as well. Earlier class, of course.

36. Holger Cahill, *A Yankee Adventurer* (New York: Macaulay Co., 1930), 33–34.
37. Ibid., 42.
38. General Gordon is probably remembered most for his death at the fall of Khartoum in 1885.
39. Cahill, *A Yankee Adventurer*, 217.
40. *Some Events of Boston and Its Neighbors* vol. 12 (Boston: State Street Trust Co., 1917), 60.

Entertaining Salem

41. His horse's name was Down-the-Banks.
42. Mary Harrod Northend, *Memories of Old Salem* (New York: Moffat, Yard and Co., 1917), 247–48.
43. Alice Morse Earle, *Customs and Fashions in Old New England* (New York: Charles Scribner's Sons, 1896), 244.
44. Henry M. Brooks, *The Olden Time Series: Quaint and Curious Advertisements* (Boston: Ticknor and Co., 1886), 86–87.
45. He'd probably take note of the Revolutionaries' tactics and become American Guerilla-Warfare Pig.
46. According to the Arabian Horse Association, the first breeder of consequence in America didn't come along for another decade.
47. When Emily Soldene visited Salem in 1889, she was told the Essex House stable was haunted by ghostly horses that could be heard munching in the empty building. She seems to have sided with a doubter, who ascribed the noise to rats.
48. Northend, *Memories of Old Salem*, 232.
49. Hurd, ed., *History of Essex County*, 179.
50. Ibid.
51. She compared it to the British Museum and was extremely unimpressed.
52. *Radio Broadcast* of July 1922 reports Bell "finding his own invention a source of annoyance, had it removed from his room."
53. Bell thought telephones should be answered with "Hoy!" not "Hello."
54. *The Telephone Review Supplement* vol. 6, no. 1 (January 1915): xviii.

Literary Salem

55. Spoiler alert! In an interesting twist, the marvelous city is revealed to be in actuality an amalgam of Carter's beloved New England: "Arkham is there, with its moss-grown gambrel roofs and the rocky rolling meadows behind it…" Turns out perfection actually *is* New England.

Edible Salem

56. The London Coffee House is now Red's Sandwich Shop. You can not only find other comestibles besides coffee there, but it has also won Best Breakfast every year for over twenty years in a row.
57. Baking soda.

Cats of Salem

58. "Nathaniel Hawthorne," *Education* vol. 5 (Boston: New England Publishing Co., September 1884): 109.

All that Remains…

59. Beware room 17, or so I'm told.
60. Here the room to watch out for is 325. Also room 612.
61. In August 2009 a fire ripped through the upper part of the Ropes Mansion. Probably not due to Abigail wandering around though, right? Right?
62. See! Even Washington comes to Salem for Halloween.
63. Nathaniel Hawthorne's witch-judging ancestor, and the reason Nathaniel added a *w* to his name.
64. For what it's worth, I heard one company was effectively chased out of the building, the haunting being too much trouble to deal with on a repeated basis.
65. Telluric energy pathway.

66. Gratuitous poetical reference:
Heap not on this mound
Roses that she loved so well;
Why bewilder her with roses,
That she cannot see or smell?
—Edna St. Vincent Millay, "Epitaph"

About the Author

Susanne Saville is descended from Governor Endecott and has two master's degrees, one in history and one in library science. This has aided her research into Salem's history, as have copious amounts of caffeine and chocolate. She is the author of multiple works of fiction, but writing *Hidden History of Salem* has proven the adage truth is stranger. She hopes you will visit her at www.SusanneSaville.com.

Visit us at
www.historypress.net